IMAGES
of America
LONG GROVE

The oak-hickory forest was what greeted the pioneers when they first arrived in Long Grove. The habitat was rich in harvestable wildlife and wild berries and fruits. The Native Americans had appreciated the gifts of the forest. They had used fire to maintain the balance between the woodlands and the prairies. (Burgess.)

On the cover: Pictured are William Lemker, George Umbdenstock Sr., Louisa Umbdenstock (née Pahlman), Emma, George Umbdenstock Jr. (on rocking horse), and Almina. This photograph was taken around 1886. George Umbdenstock Sr. was an early blacksmith in Long Grove. William Lemker apprenticed with Umbdenstock. His son later married Emma Umbdenstock. (LaMarche.)

IMAGES
of America

LONG GROVE

Nancy Schumm-Burgess

ARCADIA
PUBLISHING

Published by Arcadia Publishing
Charleston SC, Chicago IL, Portsmouth NH, San Francisco CA

Printed in the United States of America

Library of Congress Catalog Card Number: 2006924930

For all general information contact Arcadia Publishing at:
Telephone 843-853-2070
Fax 843-853-0044
E-mail sales@arcadiapublishing.com
For customer service and orders:
Toll-Free 1-888-313-2665

Visit us on the Internet at http://www.arcadiapublishing.com

*This book is dedicated to Maxine LaMarche
and the residents of Long Grove, past and present, whose stories have
brought our history to life. Also, I dedicate the work in this book to Todd E.
Smith, without your help I would never have finished the book.
Thank you.*

CONTENTS

ACKNOWLEDGMENTS

Special thanks to Todd E. Smith who has inspired me to follow new dreams. I extend special gratitude to Elizabeth Schumm for her translations of German text, her help was invaluable. Thank you to Al Westerman for his brilliant research. A debt of gratitude is owed to all the residents, current and past, who have donated their family images and stories to this work: Mary Lou Muehleis, Pat West, Tom Skidmore, Clayton Brown, Pat Harding, Marilyn LaMarche, Carolyn Christiansen, Alice Mae Rosedale, Michael Brickman, Cal Doughty, Mary Jo Landergan, Dave Lothspeich, and the Village of Long Grove. Thanks also to Ann Dickson of the Long Grove Historical Society for her patience. Additionally, I thank Amanda and Patrick who tolerate their kooky mother and never question her many projects.

INTRODUCTION

It began with the land. Native Americans appreciated the timber, wetlands, and prairie that covered the landscape of Long Grove before the land was officially open for settlement in the fall of 1836, but some industrious men arrived earlier. Early German travelers saw the potential and made Long Grove home. They called the town *Muttersholtz* initially after their hometown in Alsace-Lorraine in Germany. Muttersholtz translated as "mother's woods," leading legend to believe that the German's named it after their homeland's timber. In 1847, the name was Americanized to Long Grove. George Ruth, the first German pioneer in the downtown area, described Long Grove in the church's German archives, "The land was without streets and bridges and the Indians crossed the areas freely. The great fertility of the land was noticed."

There were several reasons for German migration to America. A panic in 1825 in Alsace-Lorraine sent many Germans to America to avoid the declining economy and rising populations back home. France and Germany had been fighting over the Rhine River for many generations. Eventually Alsace-Lorraine became part of France. Long Grove had the largest German settlement in Lake County, with most of them originating from the Alsace region. By 1850, they had fulfilled the basic needs of most early towns, having established a blacksmith, a church, and a general store, not necessarily in that order. The inevitable tavern would follow.

The 1930s brought a few gangsters and colorful personalities wishing for a quiet corner in the world. When paved roads made their way from the city of Chicago, the first commuters set their roots on the fertile soil in the midst of the still present forest. They resisted the mass development that would fill many farmlands in the collar communities of Chicago by establishing low-density development standards when they incorporated in 1956. By 1960, the population had only reached 640 residents.

Today the village inspires visitors to "shop, dine and stroll through history." With its quaint charm and traditional festivals that fill the streets with food and people each summer, Long Grove retains much of its early semi-rural character. Still present are many of the historic family buildings and businesses from the middle to late 1800s, including the New England–style church that was established by the first settlers.

The land still attracts newer families. Modern homes are broken by prairie fragments and nestled between large oak trees. Families have changed, the notorious have come and gone, but the land and the trees remain as a testament to the Long Grove that the Native Americans called home.

—Nancy Schumm-Burgess
February 2006

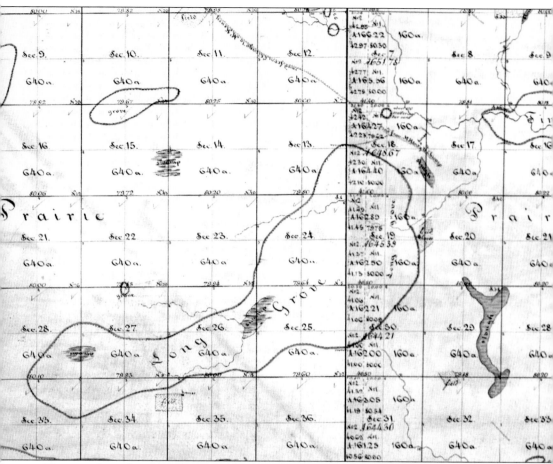

This map from the original survey of Lake County shows the land features that attracted most people to the area. The additional benefit of only paying $1.25 per acre and the freshwater streams and lakes made the land rich for pioneer settlement. (Illinois Public Domain, Federal Township Plats 1838–1842.)

One

THE PIONEERS

Some say that manifest destiny brought Europeans west. Many felt that the east coast was getting crowded and resources were depleted. Still others felt that the push west came from a need to practice religious freedom in a virgin country. Either way, the easterners came west. John Gridley was the first documented settler in Long Grove. Arriving in 1835, he set his home on a bluff along Indian Creek and raised his family there. Originally, he came from New York. Records show that he built his log cabin and the family eventually established several large farms in the northern part of the town. Meanwhile, around 1840, along Buffalo Creek, George Ruth, an Alsace German who had recently come from Pennsylvania, settled a homestead with his family. Other Germans found the area to their liking, and together they established the first church on land donated by George Ruth. Whether manifest destiny, or discriminating taste, Long Grove was formed officially in 1847 when the post office was established in Charles Stempel's store with George Ruth as postmaster.

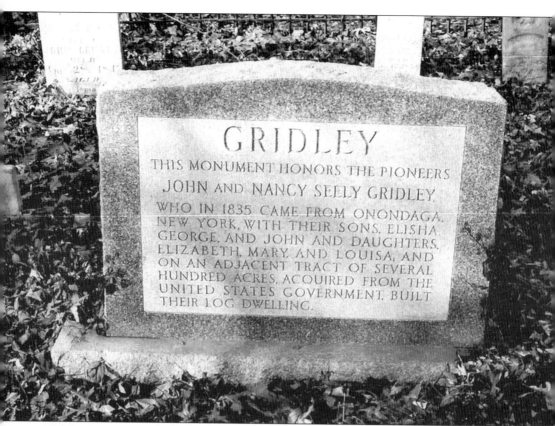

GRIDLEY

THIS MONUMENT HONORS THE PIONEERS
JOHN AND NANCY SEELY GRIDLEY,
WHO IN 1835 CAME FROM ONONDAGA,
NEW YORK, WITH THEIR SONS, ELISHA
GEORGE, AND JOHN AND DAUGHTERS,
ELIZABETH, MARY, AND LOUISA; AND
ON AN ADJACENT TRACT OF SEVERAL
HUNDRED ACRES, ACQUIRED FROM THE
UNITED STATES GOVERNMENT, BUILT
THEIR LOG DWELLING.

The Gridley family came to Lake County as early as 1835. John Gridley and Nancy Gridley (née Seely) came from Onondaga County, New York, and settled on the north side of Long Grove along Indian Creek. The Gridleys had several children who went on to purchase land in the area and raise their families. Elisha, the oldest son, married a teacher, Charlotte Hunnewell, from the school they had established for area children. After having one son, Charlotte died in 1874. Elisha served on the county board of supervisors and was a member of the general assembly in 1873 and 1874. A Gridley family descendant wrote an essay about the family in 1973, the essay said, "The official deed to the land was secured in 1843. By this time the hilltop Gridley house had been built. Gridley helped lay out the Port Clinton Road, running between Half Day and Bangs Lake, along which was built the first Gridley School." The private Gridley cemetery has 13 grave sites of adults and children. The cemetery is still maintained on the original family homesite. (Burgess.)

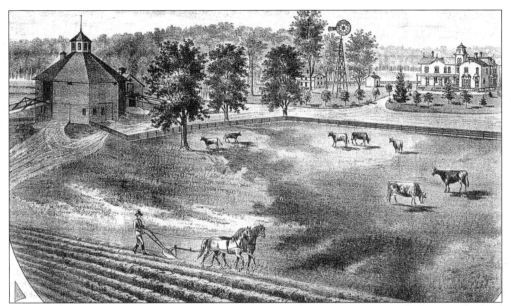

Endwood farm was built by the Gridley family in the mid-1800s on the north side of Long Grove. The estate was described in the 1875 atlas of the county as follows, "Endwood, the home of G. N. Gridley, of Vernon Township, an extensive breeder of Shorthorns, has one of the largest residences and the most expensive and complete barn in the county." In the 20th century, the farm became a resort called Oakwood. It was closed around 1940. The barn burned in 1950. (1885 Page and Company Atlas.)

The Gridley School was on local maps by 1861 and was eventually consolidated with the entire district in 1946. In that same year, there was a reunion of students at the school. Fourth from the right is Alice Courtney Keough, a former teacher of the school. She lived to be 103 years old. (LaMarche.)

The Sigwalt family arrived in Long Grove after crossing the Atlantic on the SS *Iowa* in 1844. They set up several homesteads around Long Grove. This barn was built by the Sigwalt family prior to the Civil War and was later lifted and placed on a concrete foundation. Michael Sigwalt helped to establish the first Lutheran church in town. In 1846, he served as a representative to the Evangelical Lutheran Church Synod in Ann Arbor, Michigan. He journeyed by horseback to Michigan, an epic journey for that time period, met and selected J. S. Dumser, a Lutheran missionary, to come back and serve as the first minister of the church in Long Grove. Initially, barns and private homes served as meeting places for church services. (Burgess.)

The first reverend of today's Long Grove Community Church was Rev. John Simon Dumser. He also served a church in Wheeling and possibly another in Woodstock. He had spent one year as a missionary to the Huron Indians along the shores of Lake Huron in Michigan before coming to the first Lutheran church in Long Grove. While here, he purchased 80 acres of land. With his wife, Margaretha Dumser (née Degen), he stayed in the area until late 1848. He appears on the 1850 census as still living in the area with his wife and three small children. (Long Grove Community Church.)

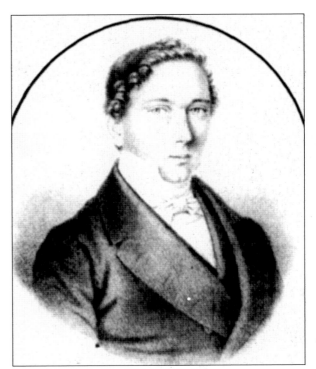

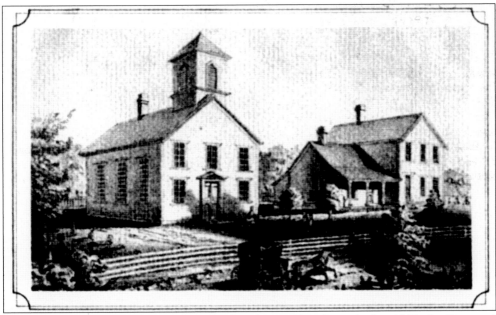

The cornerstone to the German Evangelical Lutheran Church was laid in 1847 after Reverend Dumser was located. The first service was held on Palm Sunday, April 16, 1848. This etching was created before the Civil War and presented to the church by Reverend Dumser's grandson. Services were held in German until the 1920s. There were two churches in the downtown: the German Evangelical Lutheran Church and the German Methodist Evangelical Church. The traditional Lutherans called the Methodist Evangelical churchgoers jumpers because they had left the traditional church. (Long Grove Community Church.)

In addition to helping build the first church, Michael Sigwalt served as the first postmaster in Long Grove, while the town was still named Muttersholtz. Muttersholtz was Sigwalt's hometown back in Alsace-Lorraine. His term as postmaster only lasted two-and-one-half months until the town was renamed Long Grove and George Ruth became postmaster. Family stories say that Sigwalt was quite feisty with a fiery temper. He left Long Grove in the early 1850s and set out west to seek gold in California. His ship was wrecked along the Mississippi River, and Sigwalt eventually ended up in Brazil. (Burgess.)

Several community members left to fight in the Civil War. Christoph Sauer served in the 88th Infantry along with Charles Sigwalt and his brother Jacob (Jacques). Sauer returned with a leg missing after the battle at Missionary Ridge. Jacob Sigwalt was killed at the battle of Stone River. His body was never recovered. Charles Sigwalt wrote a long diary of his time with Sherman's campaign to Atlanta. The 88th fought many battles along the way to Atlanta. The GAR (Grand Army of the Republic) was formed in 1866 by Union Army Veterans. Several of the Long Grove veterans were members of the GAR, which was a political force nationally until 1956. (Burgess.)

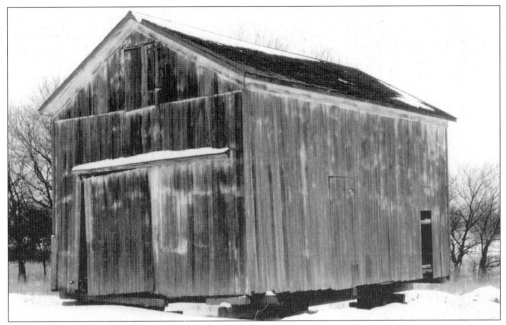

The Ruth family owned several properties in Long Grove until they disappeared from census records around 1900. The barn was probably built by Irwin Ruth, George Ruth's oldest son. According to the record, Irwin Ruth was born in Pennsylvania, where his father's family had stopped after leaving Alsace-Lorraine. Irwin Ruth and his wife, Leah, had five children. The 1870s census listed his profession as farmer. The barn is common of barns built in the mid-1850s, with traditional post-and-beam construction and hand-hewn beams forming the main framework. (C. Doughty.)

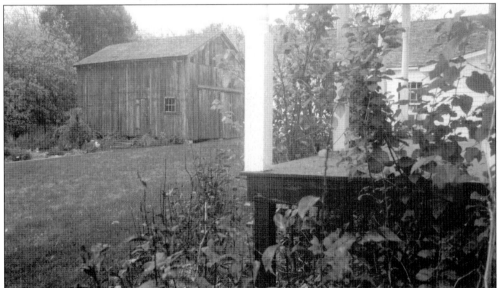

The Ruth barn has been preserved by the Long Grove Historical Society and is located behind the current village hall. Area schoolchildren visit the hands-on museum to learn about pioneer farmers. Included in the museum are old farm implements and blacksmith equipment from Long Grove blacksmiths. (C. Doughty.)

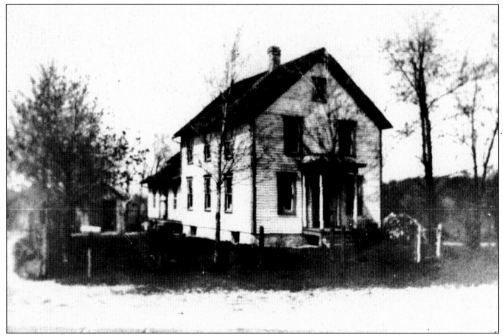

Here are two views showing the farmstead belonging to the Wickersheim family. They lived on the southwest side of Long Grove. The house and barn date from the early 1860s. The Wickersheim family claimed both French and German ancestry. They originated from Alsace-Lorraine, and family members appear on the earliest land grant maps. (M. Muehleis.)

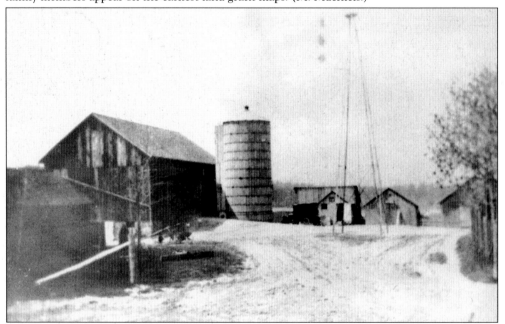

The farmstead was laid out in an orderly pattern similar to others of the time period. The barn style was similar to other pre–Civil War barns in the area. It was built during a time when Victorian family values influenced the arrangement of buildings on the farmstead. Victorians felt that a neat and tidy farmstead reflected good family values. (M. Muehleis.)

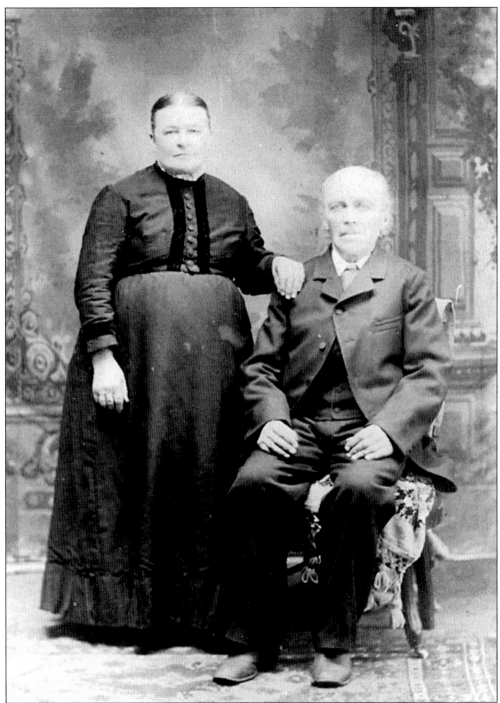

Kunigunda Wickersheim (née Popp) and John Wickersheim Jr. were married in Chicago on December 26, 1857. John Wickersheim Jr. was the oldest son of John and Maria Wickersheim who had come to Long Grove in 1847 from Riechenwier, in Alsace-Lorraine. Kunigunda had come from Stornbach, Bavaria, with her parents, John and Elizabeth Popp in 1854. Kunigunda and John Wickersheim Jr. had three children. (M. Muehleis.)

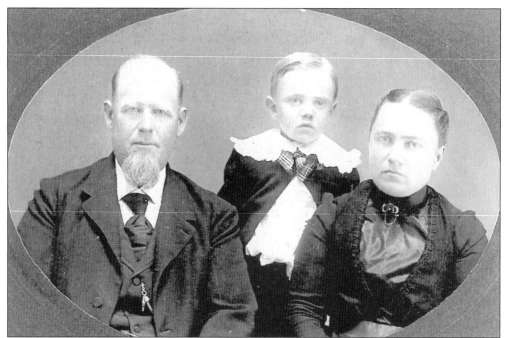

Kunigunda and John Wickersheim Jr.'s daughter Kate married a boy down the road named John Pahlman. The Pahlman family had also come to Long Grove very early. John Pahlman's parents were Hermann and Catharina Pahlman. This photograph of John Pahlman, Kate Pahlman (née Wickersheim), and their son John Jr. dates from about 1900. (M. Muehleis.)

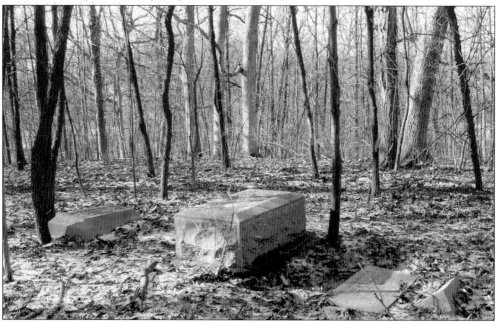

Hermann and Catharina Pahlman are buried on the family plot in today's village of Kildeer. Family cemeteries were common on old farmsteads, and pioneers had the right to set aside a portion of the land for such a purpose. There appear to be four grave sites, but the other markers have been worn down by time. (Burgess.)

Fred Wickersheim married Wilhelmina Krueger in 1886. Fred's parents were Kunigunda and John Wickersheim. Wilhelmina Wickersheim, whose nickname was Minnie, came to the United States in 1885 from Warbend, Mechlenburg, New Strelitz, Germany, with her mother, sister, and three brothers. Their father had died in Germany before they left to come to America. (M. Muehleis.)

Minnie Wickersheim's mother, Wilhelmina Krueger (née Granbow), brought her children over from Germany in 1885 to be with her daughter Fredericka's family. Fredericka was married to William Wiehrdt. They had arrived in Long Grove in 1882. (M. Muehleis.)

Fred and Minnie Wickersheim had nine children. Wilhelmina, their second daughter, died one day after she was born. This photograph, taken about 1914, shows, from left to right, Harry Wickersheim, Harold and Herbert Schroeder (neighbor children), and Anna, and Alma Wickersheim. (M. Muehleis.)

In 1940, Fred and Minnie Wickersheim's remaining children, William, Clara, Elsie, Anna, Edward, Alma, and Harry, gathered for a reunion. Elise Wickersheim, the second daughter of Fred and Minnie Wickersheim, had died a few years after she was married. Wilhelmina had died as an infant. (M. Muehleis.)

The original Archer Schoolhouse was established by Richard Archer as early as 1849. This small schoolhouse served the southwestern portion of the community until a larger building was needed in 1900. The building was rescued from destruction in 1977 and restored by the Long Grove Historical Society for use as a one-room demonstration school for local children. (C. Doughty.)

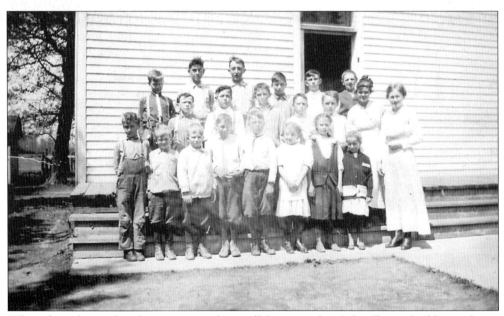

When the volume of students outgrew the small frame Archer Schoolhouse building, a larger school was built around 1900. This photograph is from around 1914 in the newer building. Harry Wickersheim is in the front row third from left. (M. Muehleis.)

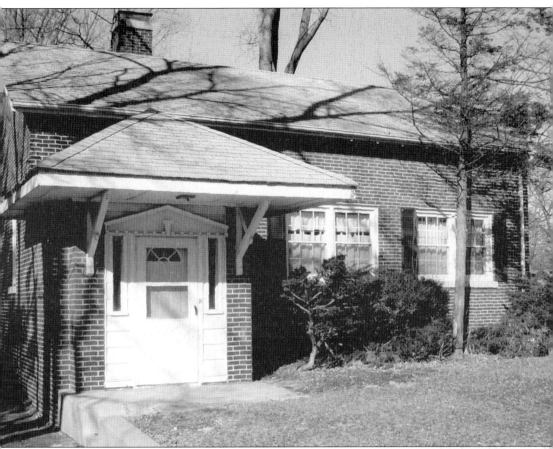

In 1928, the updated Archer School building burned down. The building was replaced with this brick building, which still stands along old Route 53. This newer building had the benefits of indoor toilets, a basement, and a furnace instead of a pot-bellied stove. The brick school was named Woodlawn after it was built. The school was converted into a home after 1946, when the schools in the area were consolidated. (Burgess.)

Souvenir

of the

Archer School

Long Grove, Illinois

The Archer School, like many schools during the late 1800s, had strong rituals of classroom behavior and expectations. While the process of education was not formal in that class attendance was not mandatory, the classrooms were very serious, formal places. Teachers were, by today's standards, very strict. It was not unusual to be beaten with a switch if one misbehaved or to be placed in a corner with a dunce cap if one acted inappropriately. These are pages from an Archer Schoolhouse souvenir of 1909. (M. Muehleis.)

ANNA H. HANSEN, Teacher

ARCHER SCHOOL
DISTRICT 99
TOWNSHIP 43
LAKE COUNTY
ILLINOIS

BOARD OF EDUCATION

GILBERT FEHLMAN, CLERK
JOHN PAHLMAN, PRES.
EDWARD BARBARAS, DIR.

Roll

Mary E. Fehlman
Oscar C. Pahlman
Magdalena W. Wolf
Alma C. Sauer
Alma H. Wickersheim
Edward P. Koch
Lucy M. Koch
Selma B. Baker
John H. Pahlman
Mary C. Lauffenburger
Ernest G. Hasemann
Henrietta E. Pahlman
Harry Umbdenstock
Anna A. Wickersheim
Ora B. Graff
Elmer O. Hasemann
Alma B. Laseke
Henry W. Laseke
Herbert R. Hasemann
Arthur Potts
Roy Koch

Moral lessons from the *McGuffey Reader*, the primary textbooks of the day, were taught rigidly at Archer School. The *McGuffey Reader* used quotations from popular literature to educate students and teach them moral lessons. Shown here are pages from an Archer Schoolhouse souvenir book of 1910. (M. Muehleis.)

I wandered through the village, Tom,
I sat beneath the tree,
 Upon the school house playground
That sheltered you and me;
 But none were left to greet me, Tom,
And few were left to know
 Who played with me upon the green,
Just forty years ago.

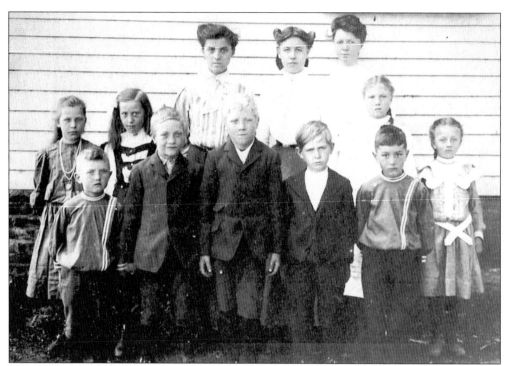

The Schultz School was located on today's Route 22, or Half Day Road. The Schultz School was consolidated with four other one-room schoolhouses in 1946. Students around 1890 pose in front of the school for their annual picture. (C. Christansen.)

The Long Grove School also served Long Grove children. The school was located on the corner of Old McHenry Road and Arlington Heights Road. It was consolidated in 1946, along with the Gridley School, Archer School, and Schultz School, into today's District 96. (Burgess.)

These school report cards are from the Long Grove School. They belonged to Ralph LaMarche, who was adopted by the Umbdenstock family in the 1940s. He attended the Long Grove School until it was consolidated with the four other one-room schools in the area. (M. LaMarche.)

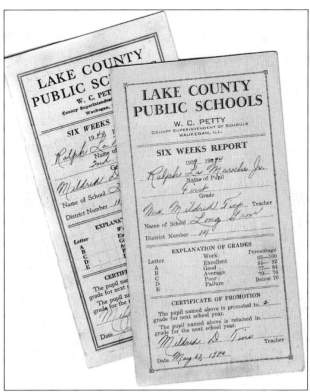

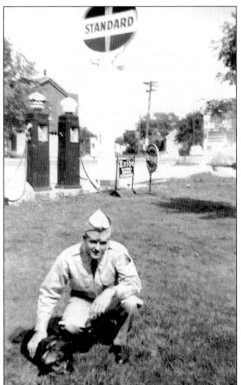

Here is Ralph LaMarche, many years after he graduated from the Long Grove School, when he was serving in the army. LaMarche was an avid photographer who took many photographs of Long Grove throughout his lifetime. After his marriage he continued to live in Long Grove. (LaMarche.)

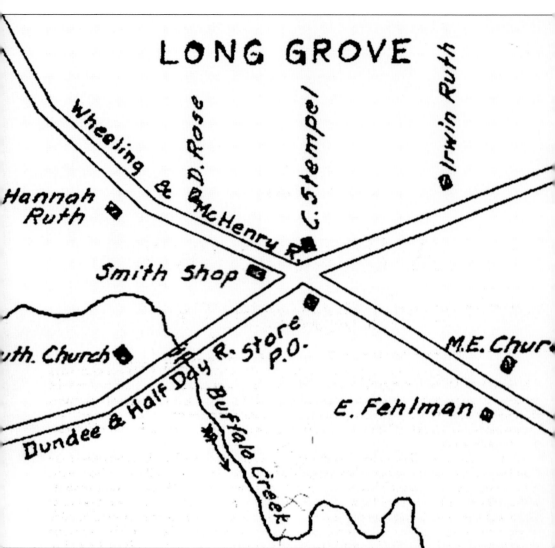

In 1861, Long Grove was one of 15 major communities in the county. This map includes cemeteries, churches, schools, homes, post offices, and mills on its list of symbols. The map was created by L. Gast Brothers and Company Lithographers out of St. Louis. (Lake County Historical Records.)

Two

A Burgeoning Community

The Civil War took its toll on families in the area, but after the war the economy was improving. The land had proven to be fertile, and the city of Chicago was calling for products from the suburbs in volume. It was the start of the gilded age, and while labor problems plagued large cities, the rural community of Long Grove prospered. Railroads were coming north, and industry was improving life for farmers. The values of education, home, church, and family of the Victorian era were still strong.

By the 1880s, Long Grove's business district was distinctly defined at the crossroads of the Dundee-Half Day Road and the Wheeling McHenry Road. There was a call for products to the major cities, and local consolidation meant that the community could deliver those products without absorbing the cities' problems. A creamery was built in town, there were two blacksmiths and a wagon maker. A hotel opened and a tavern (both within the same resourceful family). There were two general stores, and the post office was alternating between the two stores dependent upon whether the United States president was a Democrat or a Republican. The countryside was dotted with schools and churches, serving the needs of the variety of neighbors. Nestled in the woodlands, the community was taking hold and the future was looking bright.

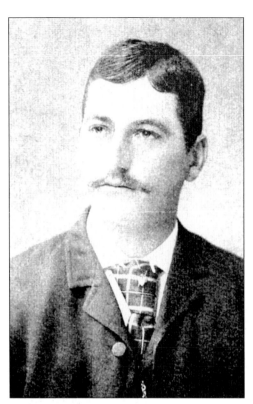

Jacob Sigwalt was one of nine children born to Casper Sigwalt, Michael's brother. He was born in Long Grove in 1868. According to family legend, he worked with his family in their creamery business around Long Grove. He married Dena Landmeier of DesPlaines, and they moved there in later years. (A. Rosedale.)

William Sigwalt was also born in Long Grove to Casper Sigwalt. He later worked as a carpenter. He married a woman from Arlington Heights and became the postmaster and mayor there. (A. Rosedale.)

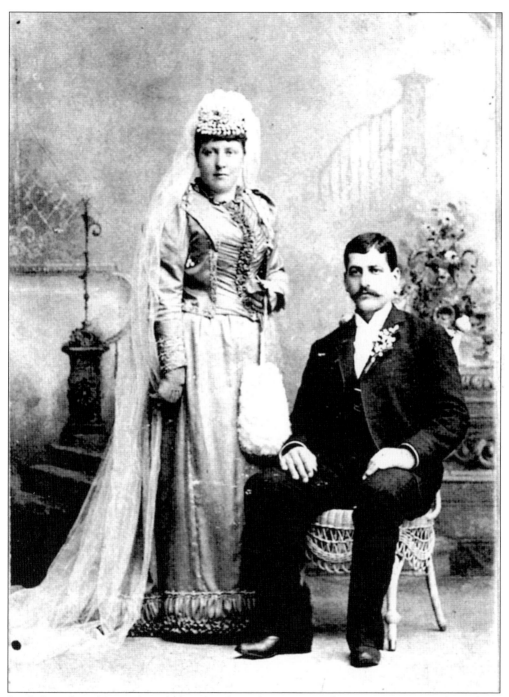

Jacob Sigwalt and Dena Sigwalt (née Landmeier) were married on June 7, 1893. Jacob was born in 1868. He was one of nine children born to Casper and Barbara Sigwalt. He was 10 years younger than the oldest child and 10 years older than the youngest child. Dena was the oldest of nine children born to Bernhard Heinrich Landmeier and Emma Landmeier (née Fechtman). Together Dena and Jacob Sigwalt had five children. Their fourth child died after only eight months of life. (A. Rosedale.)

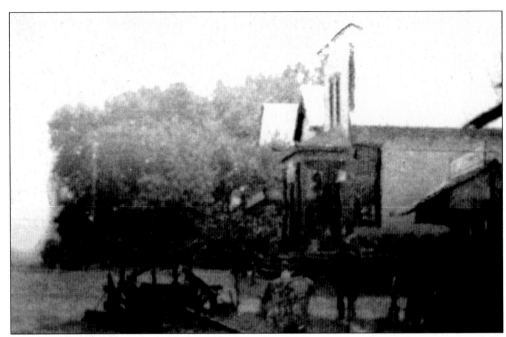

Charles Stempel opened this store around 1855. The store appears on the northeast corner of the crossroads in 1861 and was later moved to the southwest corner. Stempel came from Strasburg, Germany, and moved to Lake County on June 1, 1853. He was listed as the postmaster in Long Grove from 1855 until 1885, and then again in 1887 until 1894. The explanation given for this shift is that postal appointments were made according to political affiliations. (LaMarche.)

The Stempel store and home were built around 1853. Over the years, they have hosted small boutiques and restaurants. After the store closed, members of the Gosswiller family lived in the home. Charles Stempel was still running the store in 1900 when he was 70 years old. This building served as Charles Stempel's home. Old residents said that Charles Stempel and his competitor across the road, Christoph Sauer, would meet at 5:30 each morning in the middle of the street to establish the prices for the day. Their competition was a friendly rivalry. (Burgess.)

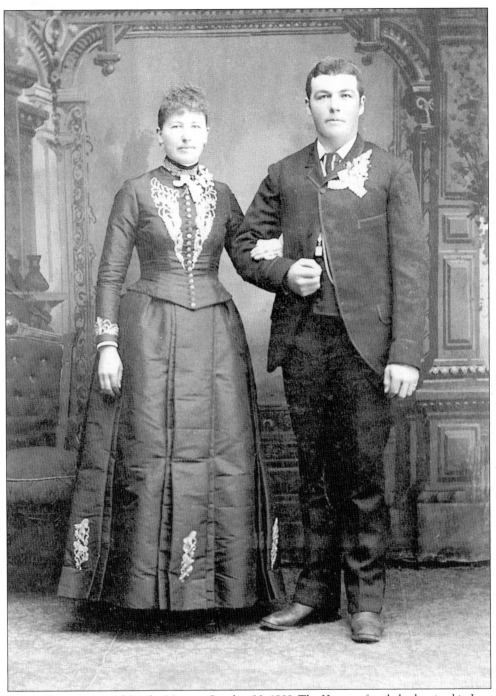

George Krueger married Bertha Voss on October 30, 1889. The Krueger family had arrived in Long Grove from Hanover around the mid-1870s. Family members had several farms in the Long Grove area for many generations. There are still roads in the area named after the Kruegers. (LaMarche.)

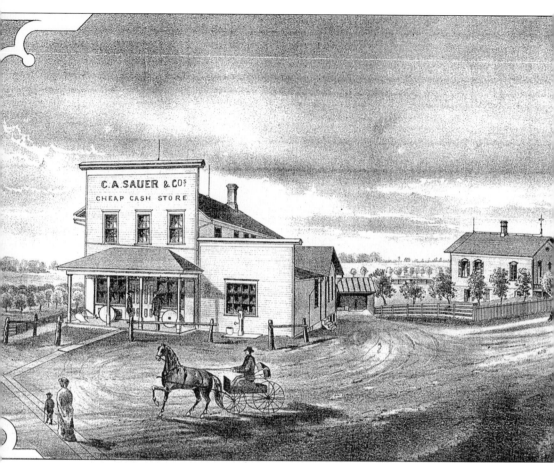

The Sauer cheap cash store was built around 1869 by Christoph Adam Sauer. Sauer's family was originally from Wurtemburg, Germany. Sauer fought in the Civil War for the 88th Illinois Infantry for the Union. He lost a leg at Missionary Ridge and returned to Illinois in 1863. His store was one of several Sauer Brothers stores in the area. One store was in Wauconda, and one was in Chicago. His father John, mother Mary, and brother Victor Sauer worked along with him in the store. By 1880, Sauer called himself a butter and cheese factory salesman in the census records. This 1885 etching shows the Sauer store and Christoph Sauer's home, which is to the right. (1885 Lake County Atlas.)

Here are Christoph Sauer and Bertha Margaretha Scheff on their wedding day, January 27, 1874. She was 14 years younger than he was. They had no children in their marriage. Christoph Sauer died on January 30, 1891. They are both buried in the Long Grove church cemetery. (T. Skidmore.)

Albert Sauer was the youngest Sauer brother, being 25 years younger than Christoph. When Christoph Sauer died in 1891, Albert married his widow, Bertha, in 1901. Albert took over management of the Sauer store in Long Grove. He was considered the most sociable of the Sauer brothers, according to local legend. He is buried in the Long Grove church cemetery. (T. Skidmore.)

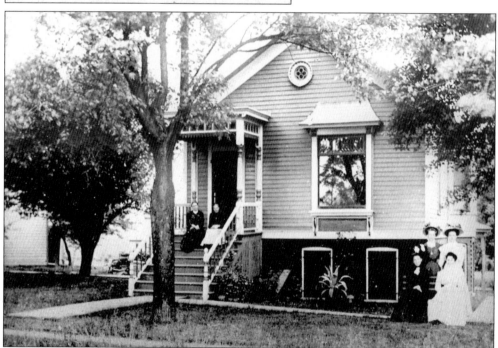

This photograph of Christoph Sauer's home was taken in the early 1900s and shows several Sauer women on the front lawn. By this time, Albert owned the home and was running the Sauer store, as Christoph had passed away in 1891. (LaMarche.)

This home located just south of Christoph and Albert Sauer's home was owned by Victor Sauer and built around 1890. Victor Sauer, according to family records, helped to start the Sauer store with his brother Christoph. Victor Sauer was 10 years younger than Christoph. (LaMarche.)

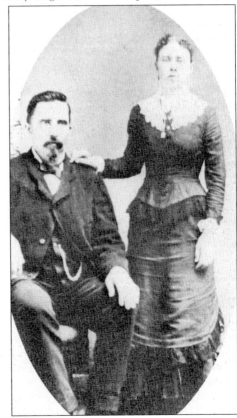

Victor Sauer married Caroline Herschberger, the daughter of Jacob Herschberger and Barbara Herschberger (née Hans). Here they are on their wedding day, September 21, 1875. They had three children together: Wilhelm, Martha, and Lily Mae Sauer. Victor lived in Long Grove until his death in 1939. (T. Skidmore.)

Friederich (Fred) Sauer was another Sauer brother. He worked as a carpenter in Long Grove. He was also known to help with work in the Sauer store when needed. Fred Sauer learned his trade working in Chicago after the Chicago Fire in 1871. His home was built around 1873. He lived in this home until around 1885, when he built a larger home west of the crossroads business district. (LaMarche.)

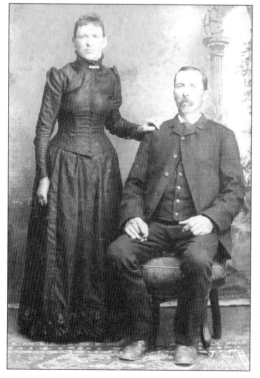

Fred Sauer and his wife, Caroline Sauer (née Gosswiller), were married on October 16, 1877, in the Long Grove church. According to family records, his family emigrated to the United States in 1855, when Fred Sauer was five years old. (T. Skidmore.)

Fred and his wife, Caroline Sauer, had eight children by 1900. From left to right, here are three of their children, Charles, Ella, and John, around 1890. All of Fred Sauer's children lived very long lives. Charles, also called Carl, lived into his 90s, Ella lived to be 93 years old, and John lived to be 97 years old. (T. Skidmore.)

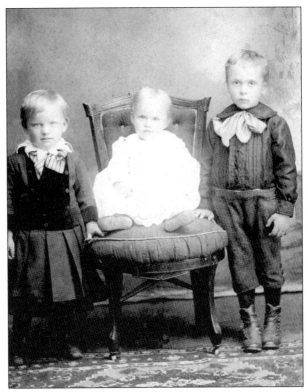

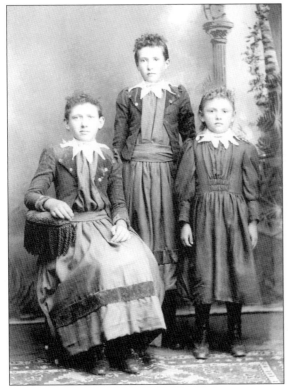

Here are three of the oldest Sauer girls in a formal portrait. From left to right, they are Bertha, Emma, and Anna Sauer. Bertha lived to be 95 years old, Emma lived to be 88 years old, Anna lived to be 99 years old. The youngest girl, Alma, almost lived to be 100 years old. (T. Skidmore.)

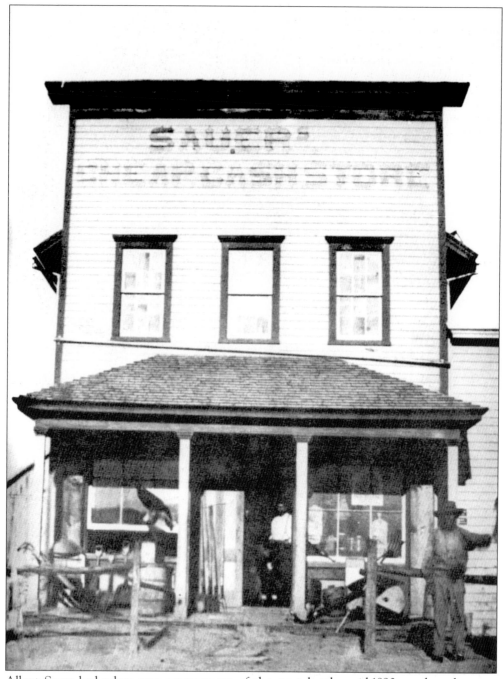

Albert Sauer had taken over management of the store by the mid-1890s, and as the store prospered he expanded the size and eventually joined in business with John Hans Jr., who had started working for the store as a clerk. The store went through several transformations in its time. An updated expansion took place around 1895–1900. (T. Skidmore.)

There were several Hans family members farming in the area by 1871. At that time, John Hans Sr. had six children, two girls and four boys. Jacob Hans had five girls and four boys. David Hans had four girls and three boys. This photograph, taken around 1909, is presumed to be the four sons of John Hans Sr.: from left to right, David, Henry, John Jr., and George. (LaMarche.)

Found in the Hans family collection, these men are presumed to be Henry (left) and David Hans around the late 1800s. They appear to be dressed as linemen or pole climbers. They would have worked on telegraph or electrical lines around 1913. These prominent jobs were coveted by young men. (LaMarche.)

John Hans was the most famous family member because he later became partners at the Sauer store with Albert Sauer. Eventually Hans purchased the store in 1914. The Hans store remained in business until the 1940s when World War II created a depression in the area. Charles and Henry Hans remained in the area as farmers. This is John Hans at his marriage to Mabel. (LaMarche.)

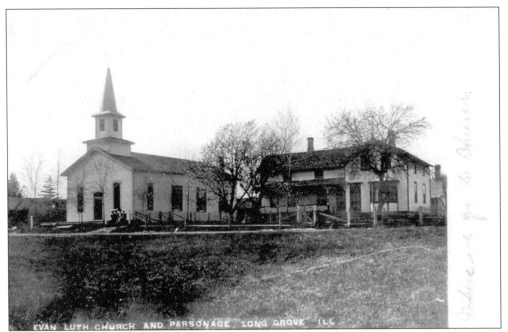

This view of the church was taken after the steeple was added in 1874. At that time, the New England style of architecture was popular because the church building was the highest structure in the area. When the bells tolled at noon each day, farmers and others would come home from the fields for lunch. Today the Long Grove Community Church (its present name) is the oldest church building still in use in the Chicago Area. (P. Halajian.)

The German Evangelical Lutheran Church of Long Grove celebrated an anniversary in 1921 and featured many of the past ministers on its legend. The terms of service for each minister were generally two to seven years in length. The ministers worked at several churches on alternating Sundays, including a sister church in Wheeling and another in Woodstock. Services were held in German until the 1920s. (P. Halajian.)

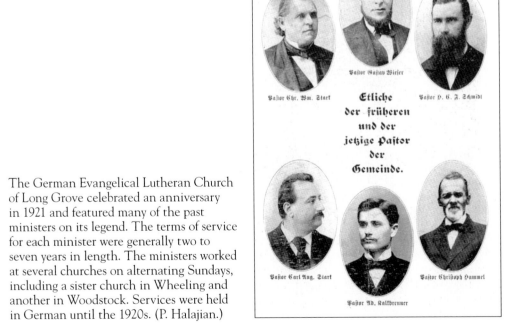

43

44

This plat of survey of the county from 1861 shows the many homes that were dotting the countryside. Life was getting busier for the small town, but farmsteads were still large in size. Children of families that lived near each other began marrying each other. Some families that had come from Alsace-Lorraine were still loyal to Germany, although France was still fighting for land rights back home, while others claimed to be from France, even though they came from the same region. (L. Gast Brothers and Company Lithographers, St. Louis.)

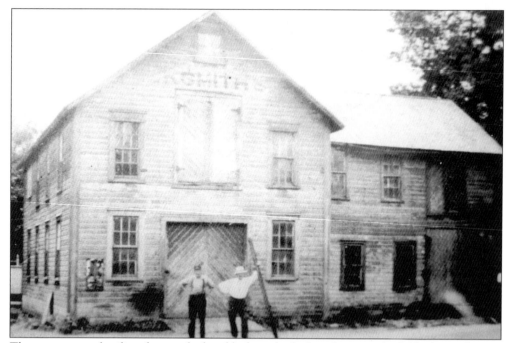

There were two families that worked as blacksmiths before the arrival of Charles and Louis Bollenbach. George Hershberger and Jacob Rose with Jacob's two sons, Daniel and Edward, appear on the 1850 census. By the 1860 census, Daniel Rose was running the business, and Charles Bollenbach, still a young man, was working with him. George Umbdenstock Sr. began training with Rose until Rose died unexpectedly. When Rose died, Joseph Stahl took over the business. Here are some industrious men in front of the Bollenbach smithy, which was established around 1880. Bollenbach's business was called Bollenbach and Son, with his son Louis. The building facade was changed in the early 1900s. (LaMarche.)

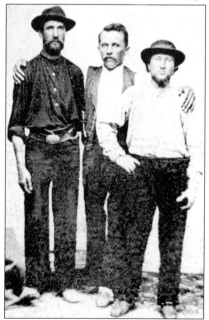

Here is a photograph of, from left to right, George Umbdenstock Sr., Christoph Sauer, and Charles Bollenbach. The community was closely tied to each other, and friendships and families were intertwined as generations moved to the next. (T. Skidmore.)

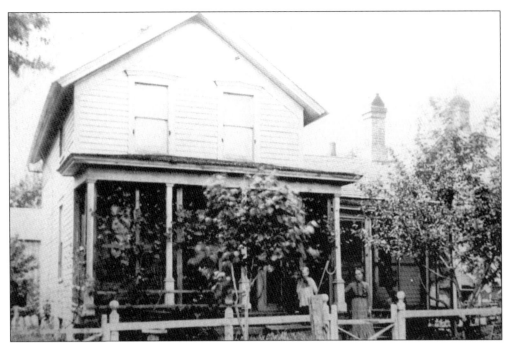

Originally located just west of Daniel Rose's smithy, the Bollenbach home was built around 1880. In later years, George Umbdenstock Jr. bought it from Charles Bollenbach when Bollenbach moved in 1905. When Umbdenstock got married he lived here with his new wife. The building burned down in 1962. (LaMarche.)

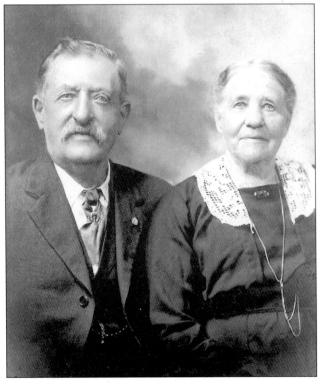

This photograph shows George Umbdenstock Sr. and Louisa Umbdenstock (née Pahlman) at their golden wedding anniversary. Family history claims that Charles Bollenbach and George Umbdenstock Sr. left Joseph Stahl's business to train in Arlington Heights with a blacksmith named Fleming. After this training, the men came back to Long Grove to go into business together, taking over Stahl's business. The partnership did not last long, and Umbdenstock stayed in the Rose/Stahl building while Bollenbach built a large building next door. (LaMarche.)

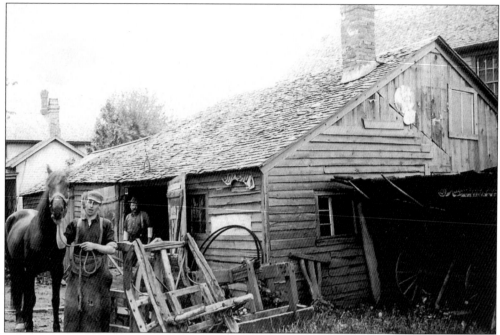

George Umbdenstock Jr. began to train with his father for the blacksmith business at age 15. In a later interview, he said that he paid a price for that work: a broken arm, leg, foot, and several kicks in the ribs. Here he is with his father at the Rose/Stahl building around 1900. (LaMarche.)

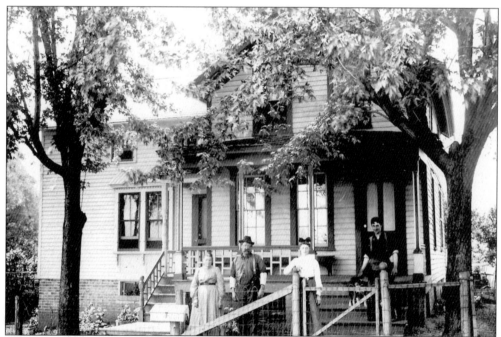

This is a picture of the George Umbdenstock Sr. home and family when George Umbdenstock Jr. was about 15. The original section of the home was built around 1870. The addition was built around 1885. (LaMarche.)

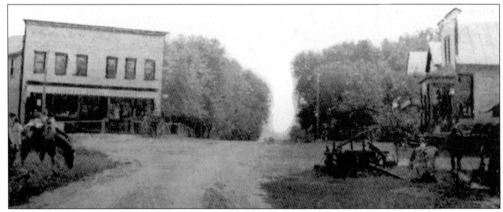

The crossroads was a bustling business center by 1899 when this picture, looking north, was taken. The first building is the Umbdenstock smithy. The large squared facade building is the Bollenbach smithy. The road leading to the tavern is behind Bollenbach's. A home belonging to John Zimmer Jr. is in the back. The photograph was taken from the top of the Sauer store. (LaMarche.)

This view is of the crossroads looking south around 1899. The Sauer store is on the left. It was expanded in the late 1890s and windows were added to the facade with an additional 20 feet of width. The facade of the Stempel store is on the right. (LaMarche.)

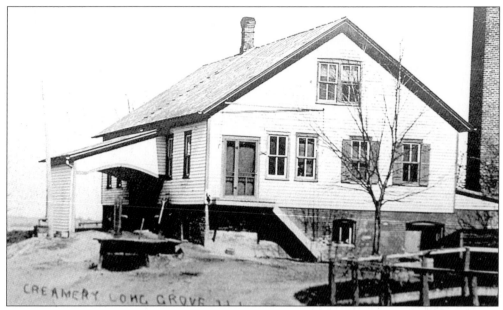

This picture shows the Long Grove Creamery, which was originally built in 1879. The building was nearly destroyed in a fire in 1897. The creamery was managed by George Quentin. Milk and cheese products were bought and sold here. This creamery was one of the busiest in the area and was said to "draw as many as 105 teams a day." In the 1970s, the Long Grove village offices were stationed in the creamery. (LaMarche.)

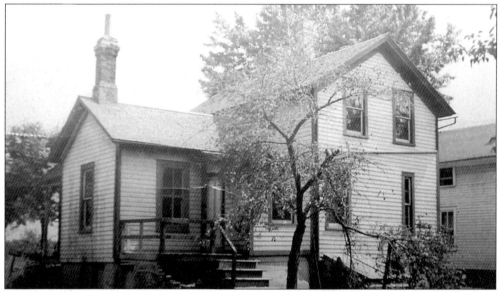

This home had several owners through the years before becoming a business in 1963. It is thought to have been built by Charles Quentin around 1860. Quentin had six children, five boys and a girl. Later it was owned by William Lemker, who in 1880 was a blacksmith's apprentice to George Umbdenstock Sr. One of his sons, Frederick, later married Emma Umbdenstock, George Umbdenstock Sr.'s daughter. In 1897, Lemker's widow sold the home for $1,300 to Frank Ruppert and his wife. When they died around 1907, Charles Hershberger's family purchased the home. (LaMarche.)

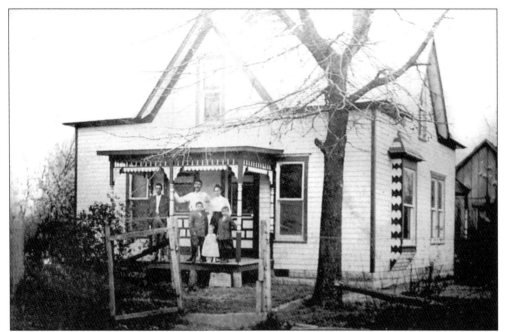

This quaint Victorian home was built by Jacob Ritzenthaler around the late 1870s. By 1900, he and his wife, Eva, had six children on a large farm at today's Twin Orchards Country Club. The home was moved by William Umbdenstock to its present location around 1928 when the Ritzenthaler family sold their large farm. (LaMarche.)

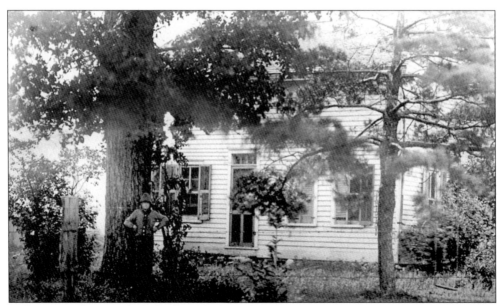

William Umbdenstock built this home for himself and his family on the west side of the crossroads. William Umbdenstock's son Harry is under the tree in this photograph. According to census records, this Umbdenstock family claimed a loyalty to France, rather than Germany, leading many to question whether local families with the same names were related. Willliam Umbdenstock's father, Mathias (Michael) Umbdenstock, claimed his origin as Germany. (LaMarche.)

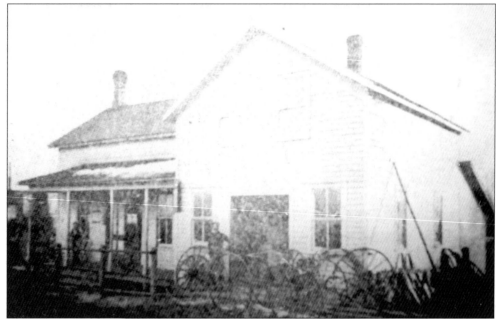

The Village Tavern began as a wagon shop owned by John Zimmer, and then William Zimmer opened it as a tavern around 1880. The Zimmers were an industrious family. In 1900, John Sr. was listed as a carriage painter, his wife, Francis, was listed as running a boardinghouse, William was a saloon keeper, and Mary was a dressmaker. The tavern has changed little over the years. The original framed interior is still intact. When William Zimmer was running the tavern he was known for his "high class of refreshments served and the good order at all times maintained." In a community of Alsatians, this was important because they were alleged to possess passionate views on politics and religion. (Burgess.)

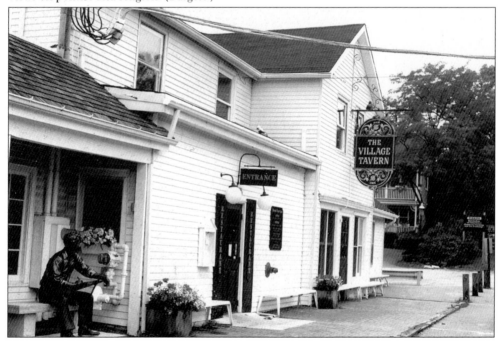

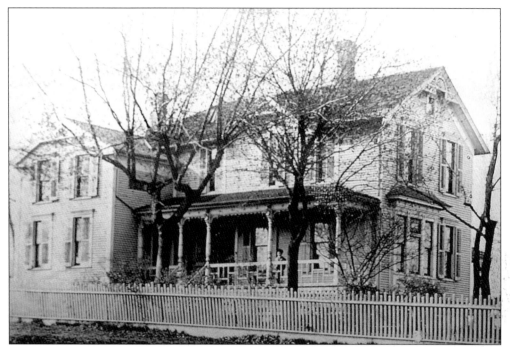

This home, belonging to John Zimmer Sr., was the local hotel, taking boarders coming from and going to Chicago. In the early 1900s, a large town hall was built just north of this home. The home boasted 10 rooms, which was considered grand for the time period. (LaMarche.)

According to local legend, John Zimmer Jr. died tragically and unexpectedly nine months after completing this home that he built for his new wife in 1898. It was located across from the hotel and just north of the Village Tavern. (LaMarche.)

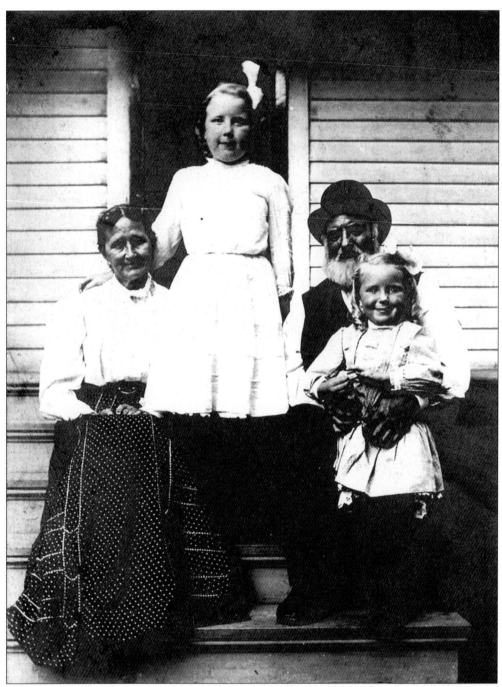

Frederick and Carolina Giss came from Alsace-Lorraine to the United States around 1856. They moved to the north side of Long Grove around 1860 and built their home. The home had a parlor that had formerly been an early church located on Half Day Road, west of Old McHenry Road. Very little is known about that church. Here, Frederick and Carolina Giss are seen with their grandchildren Anna (standing) and Cora. (LaMarche.)

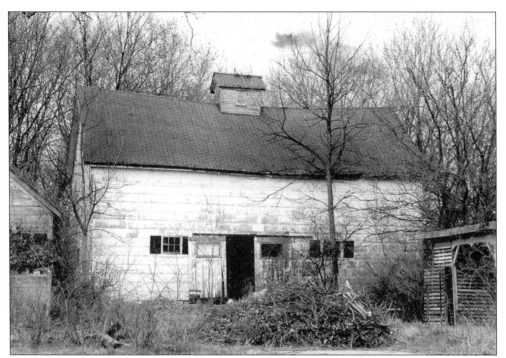

This Giss family barn was built using traditional framing techniques of the mid-1800s and was located behind the original home, which was destroyed in 1999. The cupola would have been added in the late 1800s to provide ventilation in the upper lofts. (Burgess.)

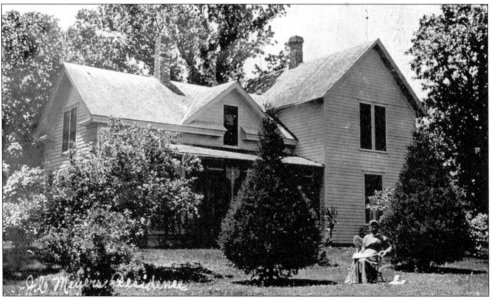

The L. B. Meyer farm stood south of Route 22 on the west side of Old McHenry Road. The Meyers farmed in the area for many years and were neighbors of the Giss family. Some members of the Meyer family were later recognized for their carpentry skills. This postcard photograph had a letter on the back that was directed to George Umbdenstock Jr., which stated that the trees, though pretty, were blocking the view of the home. (LaMarche.)

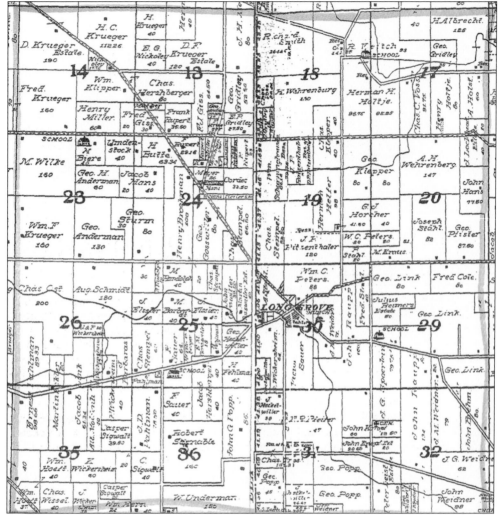

By 1907, the railroad had been established through Prairie View, to the west of Long Grove, and was conducting a significant amount of business that had earlier been transacted in the crossroads. The biggest effect that it had on the district initially was that it took the post office away from Long Grove. Eventually the creamery and a gristmill that had been in town were affected negatively by the railroad's location. (Ogle and Company Maps.)

Three

TURN OF THE CENTURY

It was the new century and Long Grove, even with its bustling crossroads, remained a small farming community. This was a time of gaiety and frolic. Children were growing up and parents were mellowed, having survived the civil war and industrial changes. Parties were held, a town hall was built, and couples were married. These were the days of the first automobile, the coming of electricity, new markets to sell to, communication improvements, and a healthy economy. Baseball was a popular pastime among the men, and regular games were played with neighboring communities. As the community slowly grew, its needs grew too, and the times changed to accommodate the growth of families.

The land had proven to be prosperous. Crops and dairy farms were successfully marketing their wares to nearby purchasers. Families built new homes with new concepts like kit homes, which accommodated the next generation of Long Grove children. The trees and countryside continued to surround the community and set it apart from its neighbors.

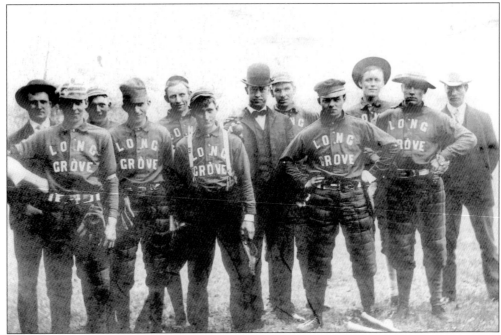

The Long Grove boys baseball team was a popular sideline for young men in the community. They played other teams from local communities. From left to right around 1905 are Henry Krieger, George Umbdenstock Jr., Charlie Sauer, Ed Welfling, Art Miller, Fred Eichler, George Quentin, George Zimmer, Bill Umbdenstock, Gus Fry, Emil Geest, and Art Moldenhauer. (LaMarche.)

Here is the men's baseball team with another year of play around 1915. In the early 1900s, there was a women's team that played ball behind the tavern (no photographs have been found). The men's team disbanded in years when little interest remained for play. (LaMarche.)

The town hall was built in 1900. Here it is semi-hidden just north of the Zimmer hotel. This is one of only two known pictures of the hall even though it was in existence until 1951. The community held popular dances there every weekend. Men paid 50¢ admission, and women were free. The building was raised with 40 men and local carpenter Charles Meyers. Meyers got paid $165 to oversee the construction. The hall burned to the ground in 1951. (LaMarche.)

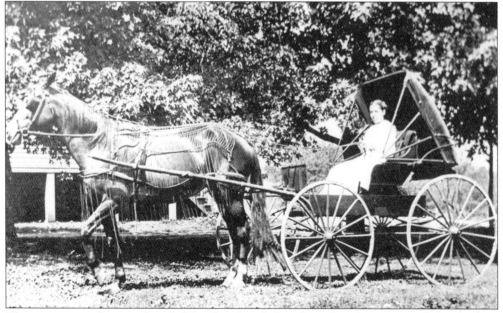

This picture is of an unidentified local girl with her dressed-up horse around 1900. It was common for young people to go on daily rides with their carriages in the summer and sleighs in the winter before the advent of the automobile. Longtime resident Ruth Lauffenberger said that even though their family had a car from the early days, her mother preferred to use the horse and buggy for her driving needs. (LaMarche.)

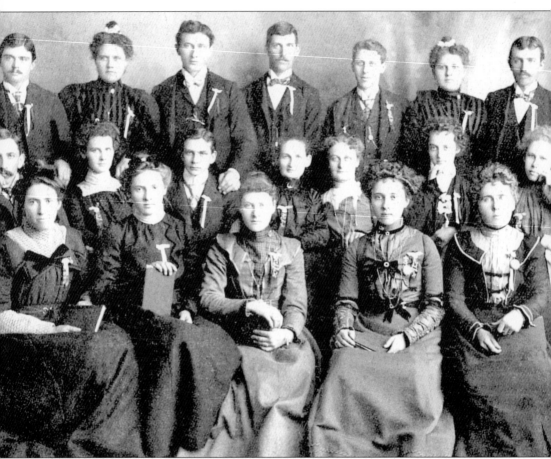

In 1900, the Evangelical Lutheran Church Choir of Long Grove was comprised of 19 youths and adults from the community. They sang at St. Peter's Church in Lake Zurich for the dedication. From left to right are (first row) Emma Sauer, Anna Sauer, Elmina Umbdenstock, Martha Sauer, and Emma Brockman (née Hershberger); (second row) Albert Sauer, Lena Schmidt, George Biere, Adeheit Schmidt (the preacher's wife), Mrs. Ahrens, Ida Gosswiller, and Margaret Schmidt; (third row) Art Wickersheim, Bertha Scharringhausen, John Hans, Fred Brockman, George Umbdenstock Jr., Lena Scharringhausen, and Charles Hershberger. (T. Skidmore.)

This photograph was found in the Hans family archives. The unidentified ladies are dressed for a ceremony, probably confirmation, around 1905. Although the girls appear in other local photographs, they were never labeled properly. (LaMarche.)

Here is another photograph from the Hans family. This girl is also dressed for confirmation. The rites of confirmation were very important in the Lutheran Church. It was a rite of passage for teenage girls. They wore white dresses typical of the Eduardian fashion of the day. (LaMarche.)

This wedding photograph is presumed to be Henry Hans at his wedding around 1910. The third generation of the original pioneer families were pairing off and starting a new generation. The marriage records for the day, however, were not always accurate and many varied between Cook County and Lake County. (LaMarche.)

Ella Sauer, born in 1890, daughter of Fred and Caroline Sauer, was growing up along with many other young girls in town. Eventually she married Frank Schar, her sister Emma's husband's brother. (T. Skidmore.)

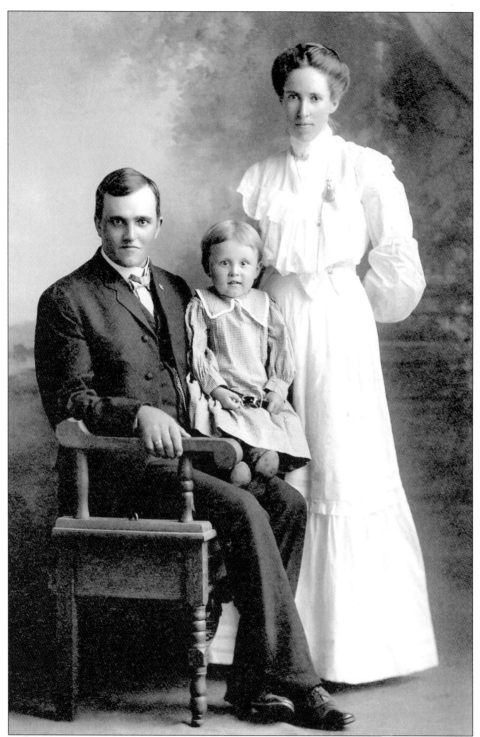

Emma Sauer, daughter of Fred and Caroline Sauer, is pictured with her husband, Wallace (Walter) Schar, and their son, John, around 1910. Emma and Walter were married on April 19, 1904. (T. Skidmore.)

Carrie Wehrenberg and George Umbdenstock Jr. met at a dance at the Wilke Farm on Route 83 and Rand Road in Arlington Heights in 1901. They went together for seven years before they married in 1908. This is a photograph of Carrie around age 16. (LaMarche.)

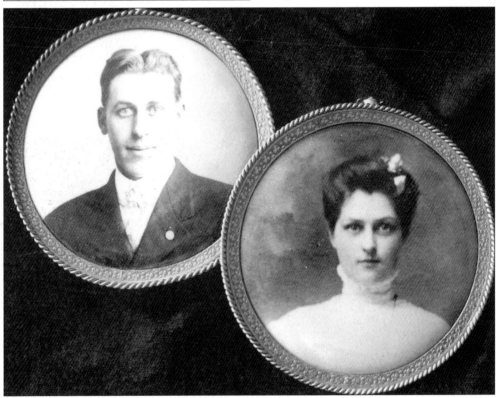

These are photographs of George Umbdenstock Jr. and Carrie Wehrenberg on their wedding day. George Umbdenstock Jr.'s family was active in the German Evangelical Lutheran Church of Long Grove, but they did not marry there because, in George Umbdenstock's words, "Services were in German up until 1935, and she [Carrie] said she wanted to know what the preacher was saying before she said, 'I do.' " (LaMarche.)

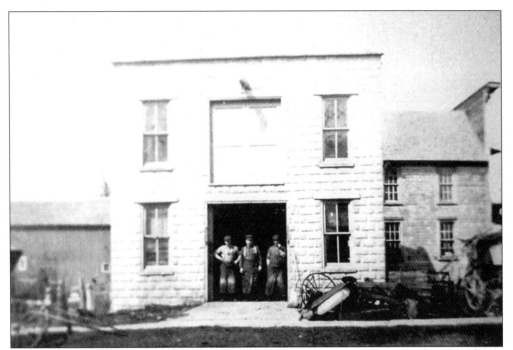

The Umbdenstocks built a new cinder-block building for their business around 1905. The new building replaced the old frame structure of the Rose/Stahl business. The large garage could accommodate several horses and some of the new machines coming on the horizon as well. (LaMarche.)

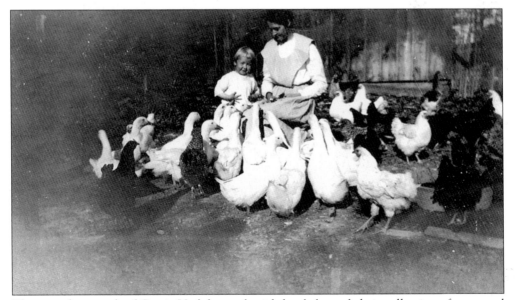

This is a photograph of Carrie Umbdenstock with her baby and their collection of geese and chickens. All of the merchants in town had small farms. Eggs and other farm produce could be exchanged for credit at the Hans store. (LaMarche.)

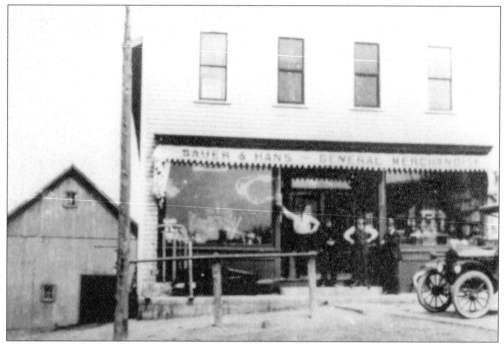

John Hans officially took over the Sauer/Hans store in 1914. In 1916, a fire destroyed the store, and Hans rebuilt it with a smaller floor plan. By this time, the Hans family store was the only general store left in town. The facade of the building went back to four windows. (LaMarche.)

In the early 1900s, it was not uncommon to hear and see the new horseless carriages as they chugged through town. They attracted a lot of attention like this car with the unidentified riders caught on film in the Umbdenstock family collection. (LaMarche.)

William Wickersheim and others went off to World War I. Throughout the county, men were called into duty. The population of the county was 55,000, and it is estimated that 4,200 left for the war. Meanwhile, at home, there were shortages and an ever-increasing need for farm production. The men left behind worked twice as hard to provide for growing demands. (M. Muehleis.)

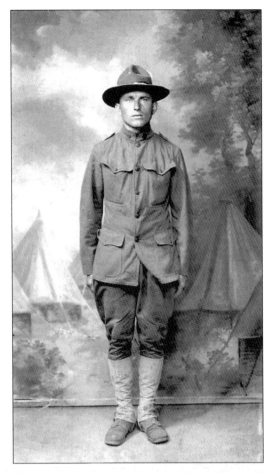

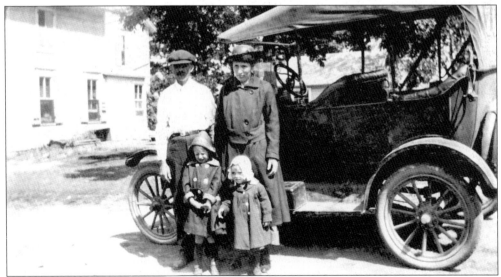

Anna Sauer married Arthur Wickersheim on April 7, 1907. They had five children. Here they are in 1922 with the youngest girls Helen and Dorothy. (T. Skidmore.)

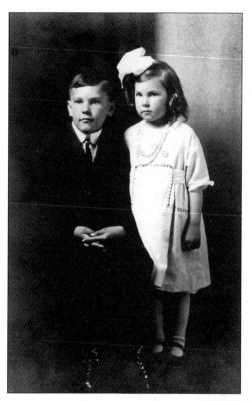

Carl and Ruth Lauffenberger lived with their parents on the southwest side of Long Grove. This is Ruth and her brother Carl in 1923. They attended the Archer School and were in attendance when the building burned down in 1928 (not the original building, but the replacement to the smaller school). The children's grandparents were Edward Lauffenberger and Clara Lauffenberger (née Wickersheim). Clara's parents were Wilhelmina and Fred Wickersheim. (M. Muehleis.)

Here is a photograph of an Archer School class taken about 1920. Alvin, Ben, and Clarence Wickersheim, the three oldest children of Anna Wickersheim (née Sauer) and Arthur Wickersheim are in the photograph. (T. Skidmore.)

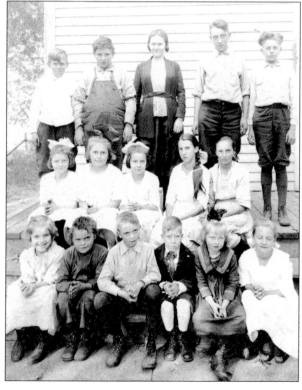

In 1942, Ruth Lauffenberger married Eldon Gadke in the Long Grove Church. She said in her family journals, "When we were first married we had an oil stove for heat and everyday I had to bring in a two gallon can of oil for the stove. In real cold weather it took two cans of oil a day." (M. Muehleis.)

George Wickersheim was born Johann Gerhart Wickersheim in Lake County in 1850. George was the son of Michael Wickersheim and Salome Wickersheim (née Brauer). His parents came to the country in 1840 from Alsace-Lorraine. He married Caroline Sigwalt on December 10, 1872. They are both buried in the Long Grove church cemetery. (T. Skidmore.)

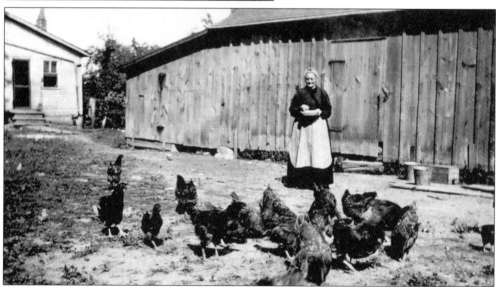

Here is Caroline Wickersheim (née Sigwalt) on the family farm feeding the Rhode Island Red bantam chickens. George and Caroline Wickersheim moved to the Wickersheim family farm where they raised three children: George, Carl, and Arthur. George Jr. died at seven years of age in 1880. (T. Skidmore.)

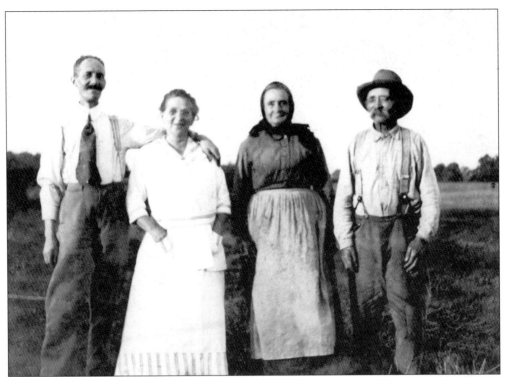

This is a photograph of Caroline Wickersheim (née Sigwalt) on the family farm with her husband George Wickersheim and their friends the Johansens (on the left). (T. Skidmore.)

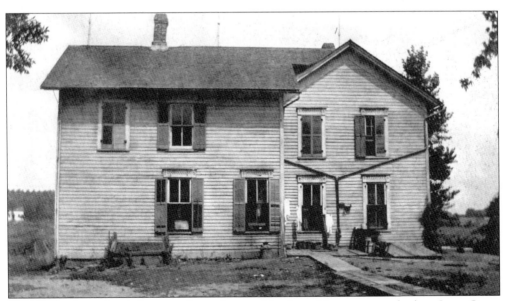

The Wickersheim family farm was located west of the Long Grove crossroads along Long Grove Road. The farm was in the family since the early settlement of the area. Here is a photograph of the farmhouse in 1942. (T. Skidmore.)

John Hans had this house built in town, closer to the store, around 1914 when he took over ownership of the store. By the 1950s, the home was falling into disrepair. (LaMarche.)

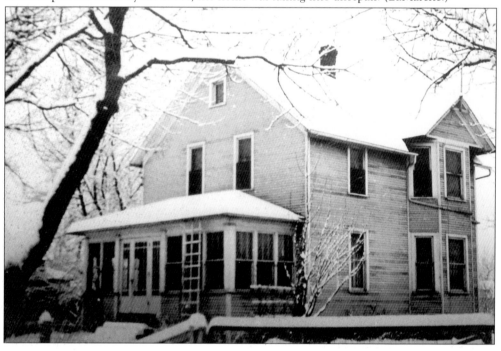

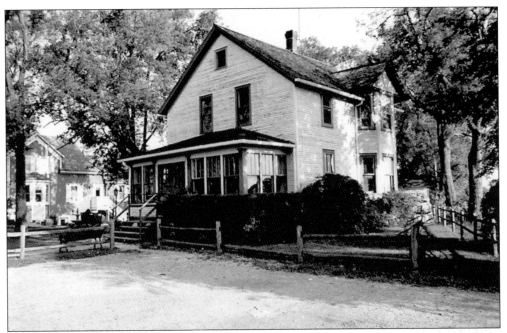

In the 1970s, the John Hans home was still a home rather than a business. In the early 1980s, the building was expanded and the first store was opened in the old home. (Above, LaMarche; below, Burgess.)

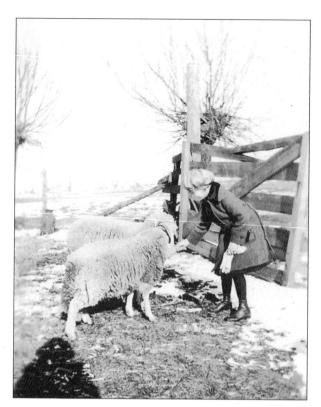

Bessie Gosswiller plays here with her sheep in town. The Gosswillers had come to Long Grove with the original settlers and remained in the area long after many others had move on. (LaMarche.)

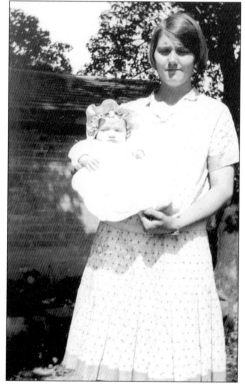

Bessie Gosswiller was the daughter of Walter and Margaretha Gosswiller. She grew up in Long Grove. Eventually she married Ralph LaMarche, and they had a son Ralph who was later raised by George and Carrie Umbdenstock. (LaMarche.)

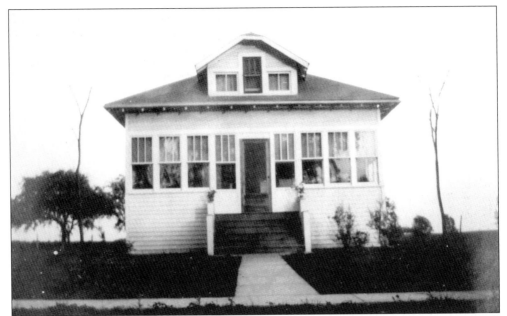

This home was built by Walter Gosswiller around the late 1920s. It was one of several Sears Roebuck homes built by Walter Gosswiller. It became a business in the early 1960s. (LaMarche.)

This is a side view of the same home. Today, after many modifications, the home is barely recognizable from its original design. (LaMarche.)

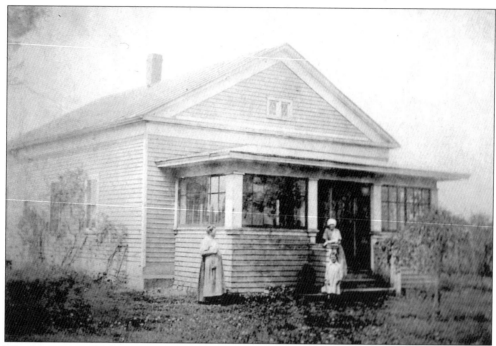

This home was a kit home of the 1920s. The style was called craftsman. It was built south of the crossroads and has remained a residence. (LaMarche.)

This was a home built in 1932 by August LaMarche. LaMarche had married Mabel Hans, John Hans's daughter. By the late 1950s, the first business had been established in the home. (LaMarche.)

This double store was built in 1928 by William Umbdenstock. The store housed a butcher on one side and a barber on the other. On the steps is Kate Eisler, whose family had a long history in Long Grove, most notoriously her brother Jacob who was well known for his skills as a blaster. Jacob had a feisty temper and once blasted a stump onto the tavern roof. (LaMarche.)

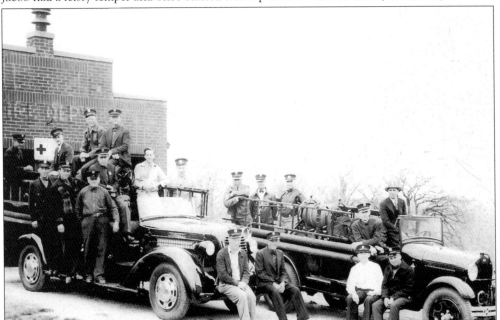

In 1929, George Umbdenstock Jr. rounded up about 32 local farmers. Together they bought a 300-gallon Model A tank truck and started the first volunteer fire department in town. Umbdenstock served as the chief for 15 years, fighting 23 fires in the area. The fire station was located on the northeast corner of the crossroads. (LaMarche.)

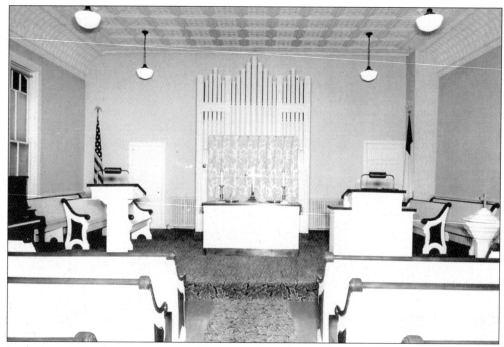

In the late 1920s, electricity was installed in the Long Grove Church interior. The metal ceiling was added with the electricity. The organ had been updated in 1902. This view of the interior is dated around 1954. (LaMarche.)

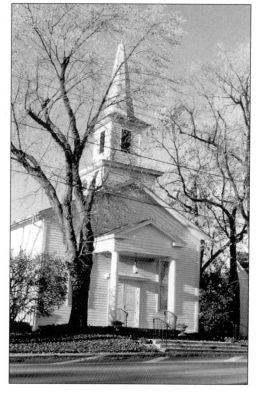

When the Long Grove Community Church celebrated 75 years of service in 1921, they were still conducting services in German. After World War I and before World War II, the German services were reduced and eventually eliminated. In part, this shift was blamed upon the children who were learning less German and because anti-German sentiment was pressuring the church to change. (Burgess.)

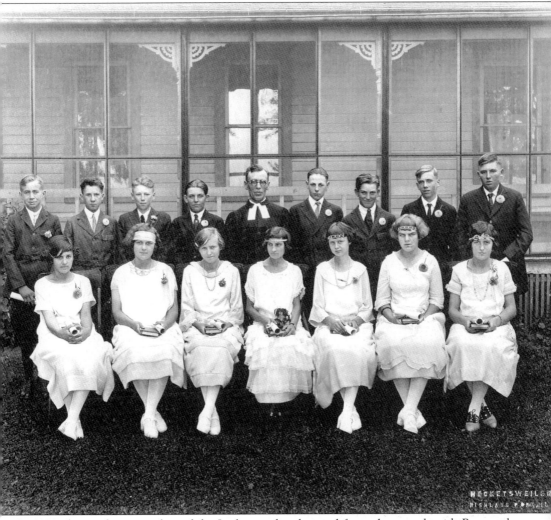

In 1924, the confirmation class of the Lutheran church posed for a photograph with Reverend Stadler. From left to right are (first row) Louella Hershberger, Ruth Haseman, Esther Berlin, Martha Voss (née Sturm), Cecilia Potts, Clara Moldenhauer, and Marion Hershberger; (second row) Edward Butt, Marvin Laseke, Ernest Hoffmeier, Clarence Moldenhauer, Reverend Stadler, Ralph Potts, Art Moldenhauer, Benjamin Wickersheim, and Alvin Wickersheim. (T. Skidmore.)

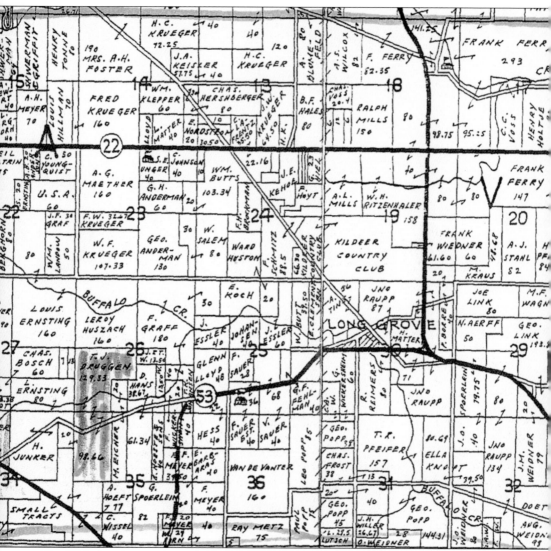

The 1936 plat of survey from the county shows the Kildeer Country Club where the Ritzenthaler farm had been on previous maps. The crossroads were too busy to define individual properties. State Route 53 had bypassed the village, both discouraging traffic and protecting the village from further expansion. There were several very large farms that competed for the local dairy business, as opposed to the earlier smaller family farms. (Stacy Map Publishers.)

Four

THE COMMUTERS

In some arenas the settlers of the 1930s were called the checkbook farmers because they came to the area and offered a check for the land. They were not real farmers in the sense of owning and working the land. Most were professionals, they raised a horse or two and maybe a couple of chickens, but farming was not their main source of income or lifestyle. They too were attracted to the land. The trees were for preserving, the ponds for swimming and fishing, and the prairie was a good place for kids to play and a good place to build individual homes.

During this time period (1920–1960), the land also attracted the criminal element. These were the retired or semi-active gangsters from Chicago who were looking for a quiet place to hide. Al Capone, Baby Face Nelson, Terry Druggen, and others made their homes throughout Lake County. They brought themselves and a federal presence to the area that still survives today.

By the 1930s, many roads were paved and railroads made it easy for a professional working in Chicago to commute to work. These commuters must have seemed a strange lot to the original country folk. They built pools and tennis courts, and country clubs soon followed. By 1950, what they also brought was a new economy. They had money to spend and nowhere to spend it, except in town. They drove automobiles that needed servicing, and they bought fresh produce because they did not necessarily grow it themselves.

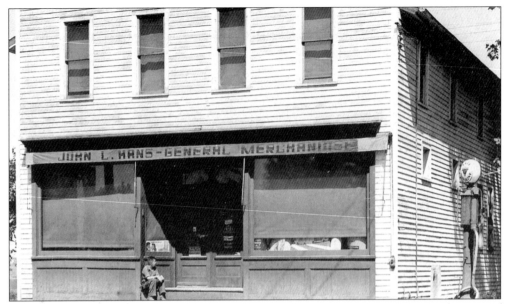

The Hans store suffered during the Depression and years following. With rationing in the years of World War II, the store, along with many other businesses in the area, was forced to close. The bypass of the village by State Route 53 also discouraged people from coming into town. (LaMarche.)

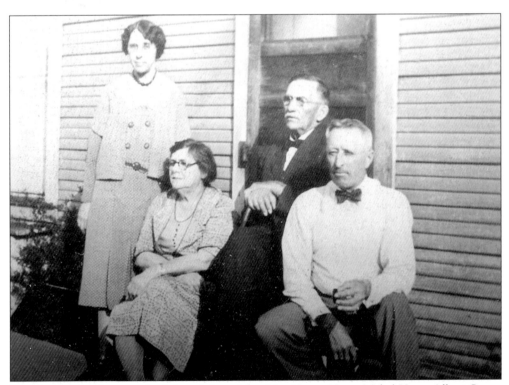

Here is a family photograph of, from left to right, Mrs. Henry Hans, Mabel Hans, Albert Sauer, and Henry Hans in later years by Victor Sauer's home. They still lived and were active in Long Grove even as the business suffered and eventually closed. (LaMarche.)

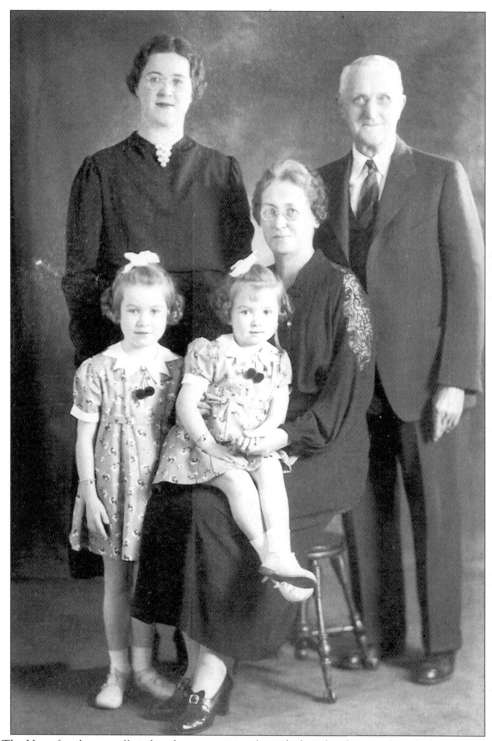

The Hans family was still tied to the community through their family even though their business was closed. Here is, from left to right, Mabel LaMarche with her parents, Mabel Hans and John Hans, and her daughters around the late 1930s. (LaMarche.)

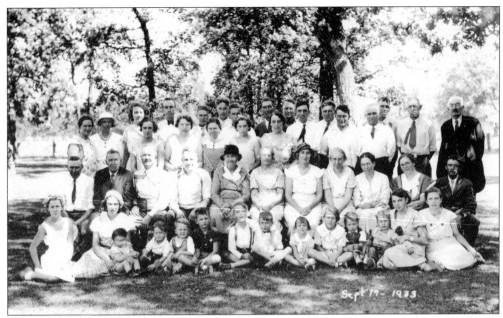

By the 1930s, the Wickersheim family had grown considerably in size. This photograph, taken at a family picnic in 1933, shows several generations of Sauers. The picnic was held in a woodland adjacent to family property that was called Stempel's Woods. In later years, the property was known as Mardan Woods and Mardan Estates. (T. Skidmore.)

This picture shows the young children of Anna and Arthur Wickersheim: Ben, Alvin, Clarence, Dorothy, and Helen. Farming in the 1930s was a tough business, and it was a time when many families left the traditional farm to pursue other occupations. (P. West.)

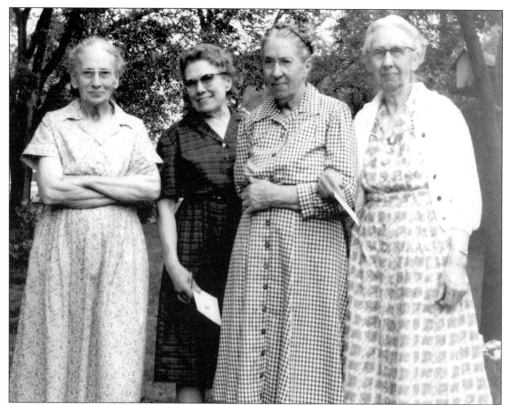

From left to right, Anna Wickersheim, Ella Schar, Emma Schar, and Bertha Wenegar, all daughters of Frederick Sauer, are at a reunion in 1962. The Sauers stayed in the area. (T. Skidmore.)

This view of the Ruth farmstead was taken before the last of the cows in town left. The black angus in the field were imported to the United States around 1873 from Scotland. This farm was located west of the double store on the north side of today's Robert Parker Coffin Road. (LaMarche.)

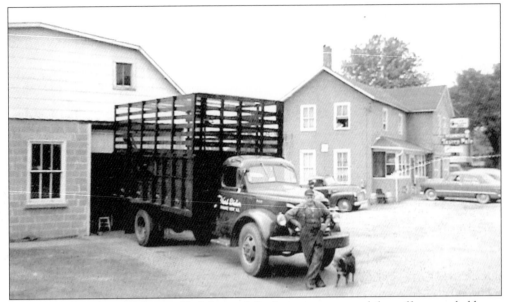

As times changed, so did George Umbdenstock Jr. As soon as automobile traffic exceeded horse traffic, George opened a service station next to the smithy. He said in an interview in his 90s that he remembered well when gas was 11¢ a gallon. He is leaning against a truck that says Didier. The Didier family had large holdings in Buffalo Grove and Prairie View. They purchased the tavern around 1941 and ran Friday night fish fries for many years. (LaMarche.)

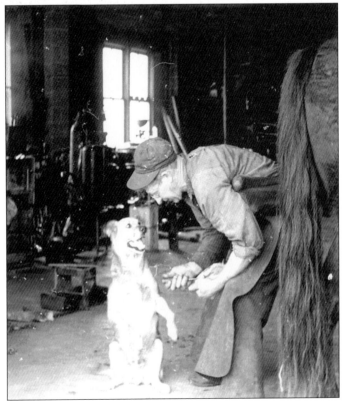

George Umbdenstock Jr. continued to work on horses for the new commuters who would ride their horses to town from their nearby properties. In this photograph, George is being interviewed by a local reporter and was joined by his favorite dog. (LaMarche.)

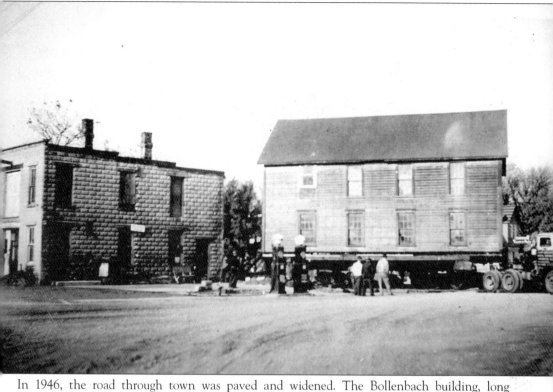

In 1946, the road through town was paved and widened. The Bollenbach building, long abandoned, was moved around the corner behind the Stempel Store. (LaMarche.)

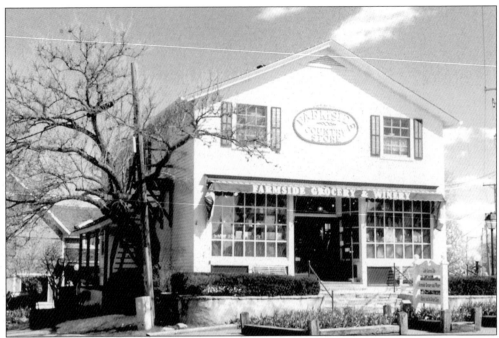

After World War II, the town began to wake up again when ambitious commuters began to open shops that would appeal to new residents. Lillian Mercer Fanning and her husband bought the Hans store, remodeled it, and opened it again as the Farmside County Store. (Burgess.)

When the downtown began to have more shops and activity, George Umbdenstock Jr. built himself a brick house just north of town where he moved with his wife, Carrie. Later his son Ralph LaMarche moved into the house with his wife, Maxine. (LaMarche.)

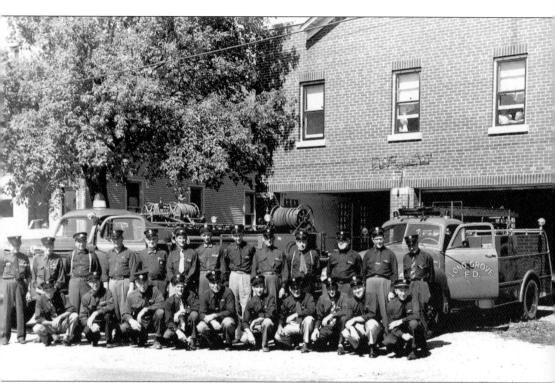

The fire station expanded for a second time to accommodate the changing countryside in 1954. Here is the fire rescue team assembled with the newer trucks. This structure was the third fire station that was built in the downtown. The second was a wooden structure that replaced the earlier brick building. (LaMarche.)

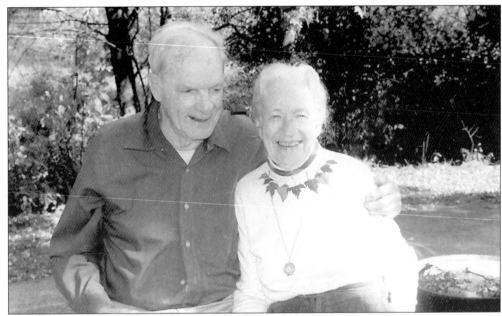

Bill Park and his wife, Virginia Park, who later wrote a book and many historical articles about the area, moved to Willowbrook Woods in the mid-1930s. There they raised their children and formed a strong neighborhood with other commuters. Virginia and Bill were active in the community well into their later years. Bill ran for village president when he was 88 years old in 1996. (Burgess, photograph taken by Robert Achor.)

Willowbrook Farm was one of the first large farms to be sold to the new commuters. The Wilke family, owners of Do-All Industries, purchased several hundred acres of land and built several homes and barns on the property. They had lagoons, orchards, a nursery, a dance and art studio, tennis courts, and swimming pools. They hosted many neighborhood parties in their estate home, which featured an indoor pool. This view of the road shows the farm in the distance. Here Jon Harding views Indian Creek along Willowbrook Road. (P. Harding.)

The pastures of Willowbrook Farm were interspersed with prairies and orchards. Note the pig running from the photographer. Commuters still living in the area described the countryside as a "sleepy farm community." The countryside afforded peace and privacy. (P. Harding.)

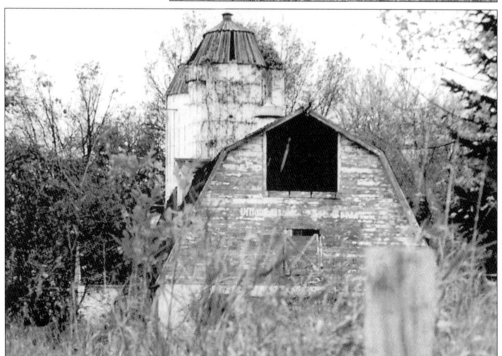

The farm suffered a fire in the 1970s and eventually was sold and torn down in the 1990s. Before it was lost, the barn still had the name fading on the old paint. (Burgess.)

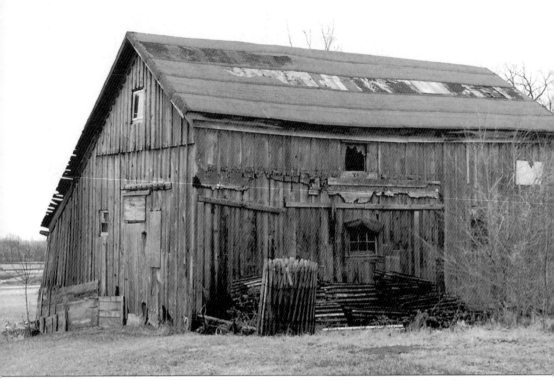

In the early 1930s, Frank Ferry of Winnetka purchased 520 acres of land on the north side of town and opened the Ferry Hill Dairy with his son Robert Hill. This barn was one of the earlier framed buildings on the property. The business home delivered milk from Highland Park down to Wilmette. According to Robert Hill, who documented his farm in an oral history, a pasteurizing plant was on the farm. Most of the farms were share-leased with Frank Ferry, meaning that there were several farm managers, and they delivered the milk to the dairy. When Frank died in 1948, Robert Hill considered continuing the farm, but the business was tough. Competitors would contaminate milk or shoot holes in trucks of opposing businesses. Consequently, Hill closed the farm. (Burgess.)

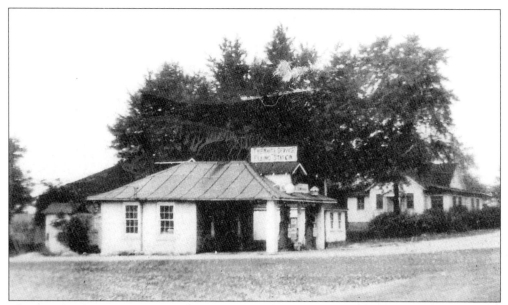

The Butt family had lived for many years on the corners of Route 22 and Old McHenry Road, called Butts Corners. The family opened a pop stand for the growing community in the late 1930s. The service station sold soda pop and gasoline and collected milk from local farmers. (Butt family archives.)

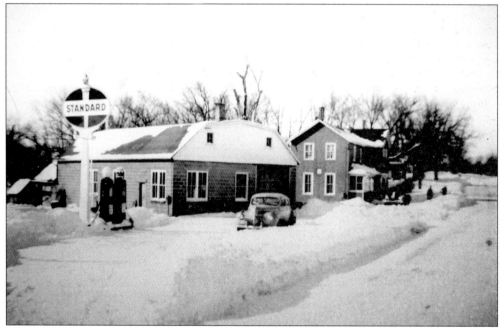

In the downtown area, the Umbdenstock garage grew in the 1950s. The tavern was growing also as a regular crowd gathered for regular Friday night fish fries, music nights, and community fund-raisers, which Norma Sayles added after she purchased the tavern from the Didier family. This is the tavern behind the service station. (LaMarche.)

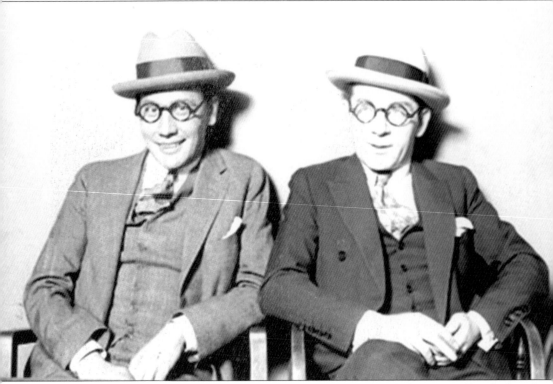

Frankie Lake (left) and his partner Terri Druggen were associates of Al Capone. They had made millions bootlegging during Prohibition and running an area between Cicero and Chicago's Little Italy. Their gang was called the Valley Gang. In 1932, Druggen was arrested and served time for tax evasion. In the late 1920s, he bought several hundred acres of land along Long Grove Road. He retired in this home in the mid-1930s. Druggen had health problems later in life, and he lived with a few nurses and an iron lung. His home, when it was sold to Norma Sayles in the early 1950s, had bullet holes in the gutters. (Chicago Historical Society Photographer, Chicago Daily News photographs, print #DN-0079320.)

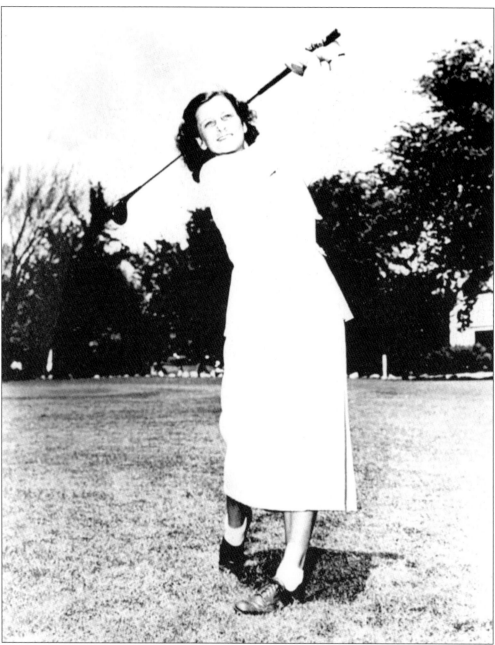

Babe Didriksen Zaharias was born in 1914 in Beaumont, Texas. During her lifetime she was considered the top woman athlete of the 20th century. She excelled in basketball, track and field, and golf. In 1983, she was installed in the U.S. Olympic Hall of Fame. In Long Grove, she served as the golf professional at the Kildeer Country Club, later called Twin Orchards. She lived on the corner of Route 83 and Oakwood Road during her time here. It was said that she hit golf balls inside her house and left many dents in the interior walls. (Hargrett Rare Book and Manuscript Library, University of Georgia Libraries.)

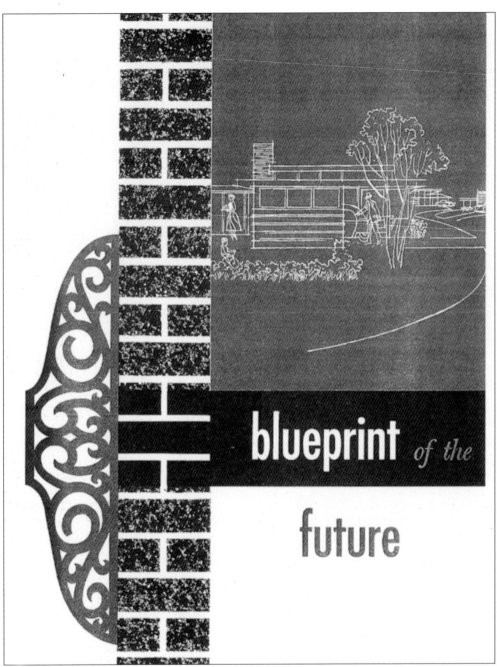

In 1954, a local developer named Joseph Brickman presented a plan for the area that would dramatically change the landscape of western Long Grove. He called his plan the Blueprint for the Future. The blueprint would create an entire city where farmland and forest presently stood. Neighbors in the area rallied together to protest the plan and protect the area. (M. Brickman.)

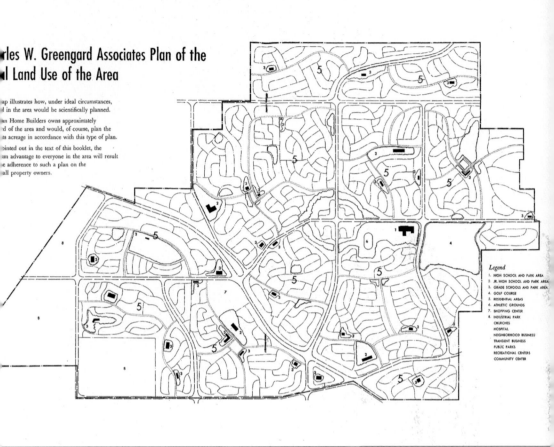

les W. Greengard Associates Plan of the
l Land Use of the Area

ap illustrates how, under ideal circumstances,
d in the area would be scientifically planned.

an Home Builders owns approximately
d of the area and would, of course, plan the
ts acreage in accordance with this type of plan.

pointed out in the text of this booklet, the
um advantage to everyone in the area will result
e adherence to such a plan on the
all property owners.

Legend
1. HIGH SCHOOL AND PARK AREA
2. JR. HIGH SCHOOL AND PARK AREA
3. GRADE SCHOOLS AND PARK AREA
4. GOLF COURSE
5. RESIDENTIAL AREAS
6. ATHLETIC GROUNDS
7. SHOPPING CENTER
8. INDUSTRIAL PARK
 CHURCHES
 HOSPITAL
 NEIGHBORHOOD BUSINESS
 TRANSIENT BUSINESS
 PUBLIC PARKS
 RECREATIONAL CENTERS
 COMMUNITY CENTER

Brickman's plan would take 15 years to implement and would include the following: 16,000 single-family homes, 6,000 apartments, one high school, four junior high schools, 29 grade schools, one country club, 10 church sites, an industrial area, and a central shopping area to accommodate all the community needs. The idea was revolutionary at the time and quite controversial. (M. Brickman.)

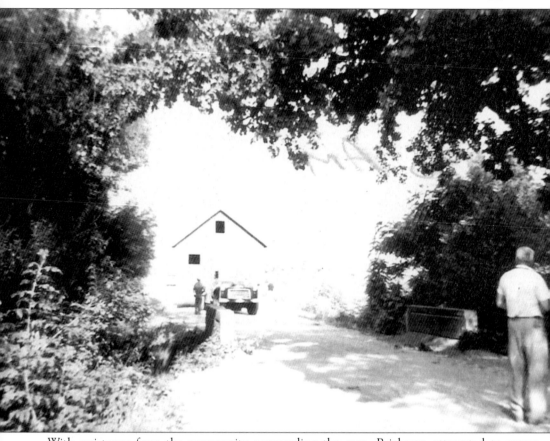

With resistance from the community surrounding the area, Brickman attempted to secure support by developing some of the land that he already owned. On a Saturday in 1956, he began by moving a barn down the roadway across a creek. The move was noticed by neighbors, and conflict ensued. Trees stretching across the creek blocked the barn's progress. This photograph shows the barn coming down the road. As the tree problem was assessed, neighbor's tempers escalated and a gun appeared, Brickman backed down. The barn returned to its former home, the branches were preserved, and neighbors calmed down. Eventually the fight was taken to the Illinois Supreme Court, and the development was never built. Brickman did find other communities willing to adopt his plan. Neighbors here incorporated the three villages of Kildeer, Hawthorn Woods, and Long Grove to protect them in the future. (Clayton Brown.)

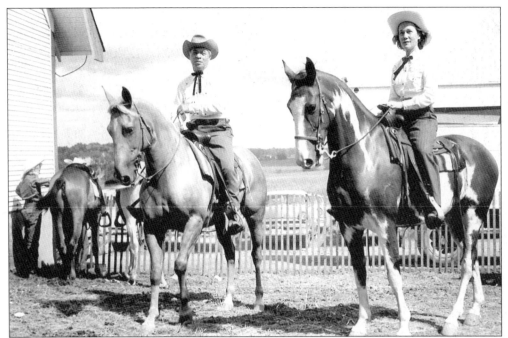

This is Joseph Brickman and his wife on their favorite horses. Brickman owned 350 acres of farmland south of town where he bred horses. While the controversy over the development was going on, and for years after, his farm hosted several rodeos. The events raised money for local schools and churches. (M. Brickman.)

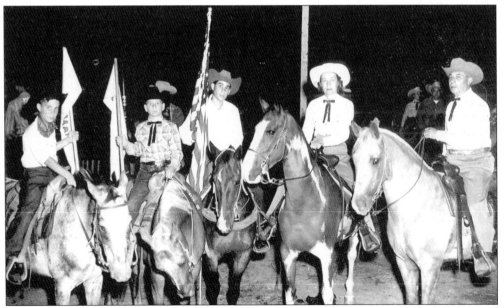

This is the Brickman family at one of their many rodeos. The Brickmans spent weekends at the Long Grove farm. Their farm had been owned by gangster Terri Druggen, and there were many rumors of the former owners hosting gambling rings and illegal activities. Local boys remember exploring the secret corners of the farm, telling stories of the gangsters who came before. (M. Brickman.)

CONTEST RODEO

Friday
Evening, 8 P.M.

Saturday **Sunday**
Evening, 8 P.M. Afternoon, 2 P.M.

SEPTEMBER 5 - 6 - 7

EVENT	PURSE ADDED TO ENTRY FEES
BAREBACK BRONC	$100.00
SADDLE BRONC	100.00
CLOVER LEAF BARREL RACE	25.00
FLAG RACE	25.00
CALF ROPING	100.00
BULL DOGGING	100.00
SPEED AND ACTION	25.00
WAND WEAVING	25.00
BULL RIDING	100.00

Brickman's Long Grove Farms

Route 1, Box 345A Prairie View, Illinois

On Long Grove Road one mile east of Rand Road (Route 12)
Three miles south of Lake Zurich Phone GEneral 8-1388
See directional Map on reverse side.

The rodeos were advertised locally. This sign is from the early 1960s. Residents and spectators would pack the stands, and cars would line up along Long Grove Road during the rodeos. (M. Brickman.)

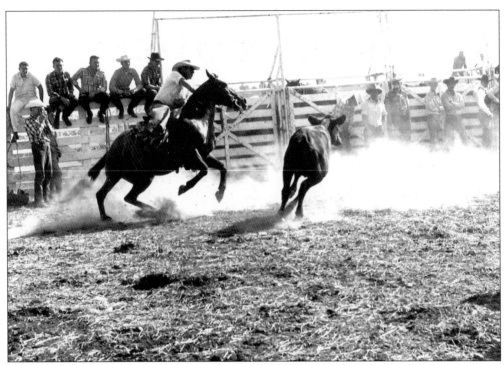

Here are photographs from the rodeo. (M. Brickman.)

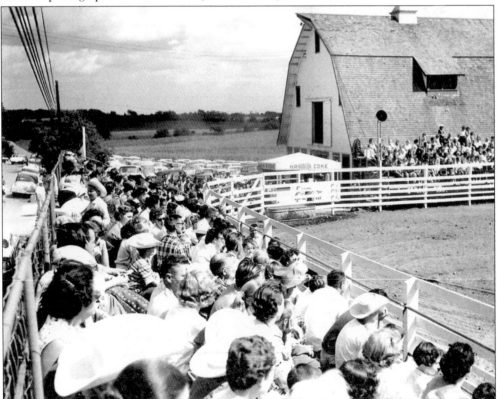

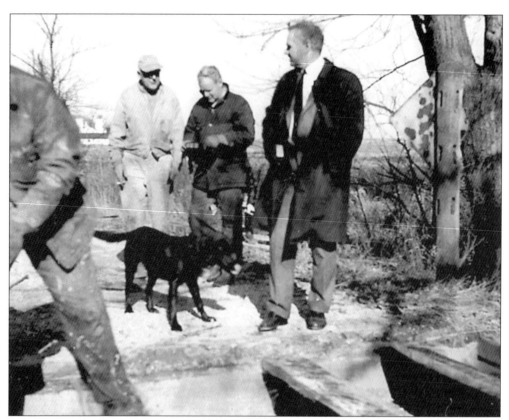

When a new bridge was needed over the many creeks in Long Grove, neighbors would get together and build it. In the early 1960s, neighbors worked on building a new bridge along Willowbrook Road. Here are an unknown neighbor, Bill Park, and Bob Coffin. (P. Harding.)

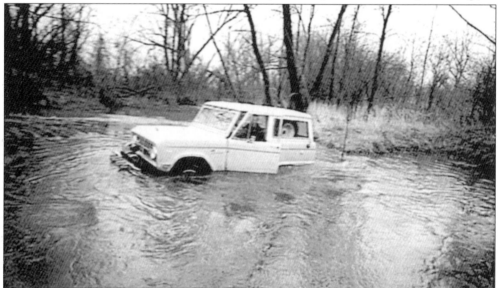

Sometimes the bridges would wash out and the roads would flood like this event in 1969. The families would wait until the water receded and then retrieve the vehicle. (P. Harding.)

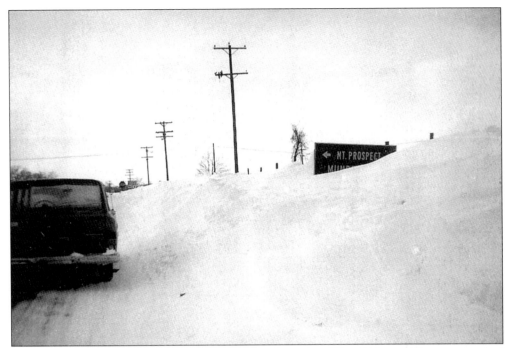

In 1967, a large snow storm hit the area. Twenty eight inches fell in 24 hours. The snow reached up to home windows. It was days before most people shoveled out of their country roads. The snow on the road covered local signs along Route 22 facing west. (P. Harding.)

Here is the same corner facing east on Route 22 near Route 83 with a similar sign during the summer. (P. Harding.)

At the corners of Routes 22 and 83, competing farm stands stood. Seasonally they provided fresh produce for the local families. This photograph is of the stand that was located on the northwest corner. (P. Harding.)

There were still active farms in the late 1960s, although not many. Most of these farms belonged to the last generation of farmers in the community. They struggled with the desire to sell the land to development and to remain active in the business of their lives. By 1980, land that remained open was farmed, but the farmers did not live on the property. This farm was located along Route 22 east of Route 83. (P. Harding.)

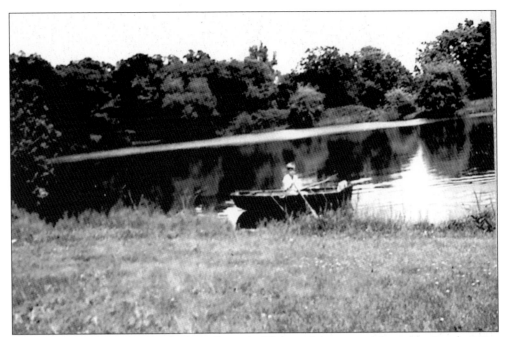

Several properties in the area had small ponds. The ponds were used for swimming, boating, and fishing. In 1967, Jon Harding enjoyed maneuvering around the family pond. In the winter, skating and fort building were favorite pastimes. (P. Harding.)

Twin Orchards Country Club, formerly called Kildeer Country Club, provided golf and entertainment for the new suburbanites. The club was a good place for local children to work in the long summer months. This photograph was taken by Pat Harding as her daughter began a job at the club. In the 1970s, Hillcrest Country Club was built on the south side of town. In the 1990s, Royal Melbourne was built on the north side of town. (P. Harding.)

Through the years, George Umbdenstock's family remained close. Here is his sister Emma Krueger (née Umbdenstock) at a family party in the 1970s.

George and Carrie Umbdenstock celebrated their 50th wedding anniversary in 1958. Here are Carrie and George Umbdenstock with Louise Lemker, their maid of honor, and best man Charles Wherenberg. (LaMarche.)

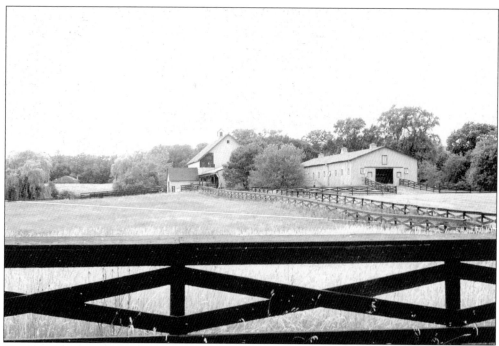

Windward Farms was one of several traditional farms converted to a horse farm around the 1950s. The oldest barn on the property dates back to the mid-1850s. (Burgess.)

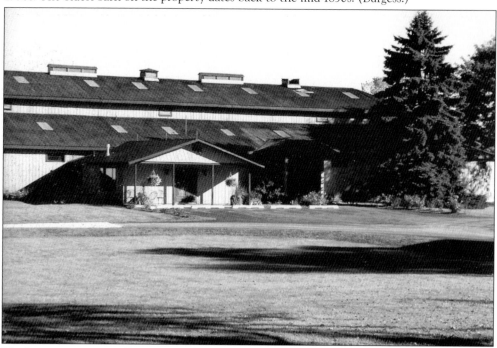

The horse community of Long Grove has been strong since the 1950s. Thoroughbred racehorses, hunters and jumpers, and draft horses have been raised by professionals and trained on farms throughout the town. Windward Farms, on the north side of town, is one of many that raised horses. (Windward Farms.)

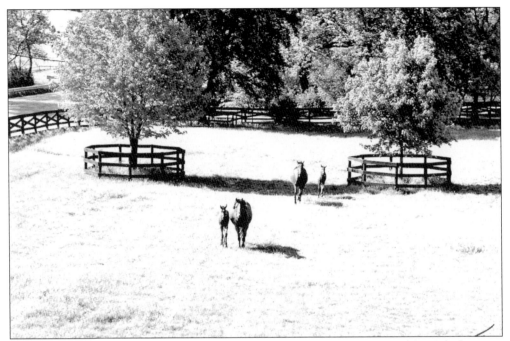

Windward Farms had one of the first pole barns built in Lake County for interior riding. The barn was built around 1950. The old barn on the property dates back to the mid-1800s. (Windward Farms.)

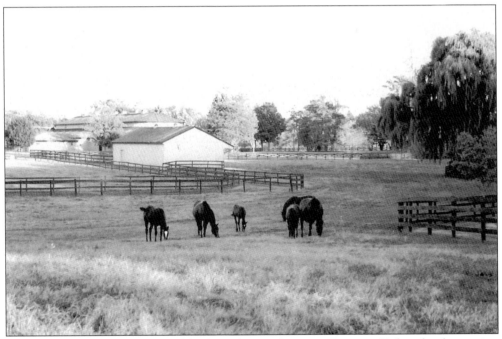

Windward Farms raised thoroughbred racehorses for over 40 years. Today the farm raises show quarter horses. It has been said that Lake County, Illinois, has one of the greatest horse populations in the country. Most of the larger farms that remain in Long Grove raise horses for professional use. (Windward Farms.)

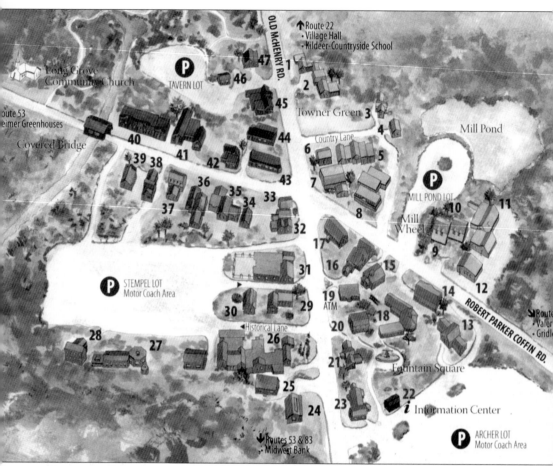

This map of the downtown is from 2005. The map shows the shopping district, which has been protected as a historic district. Many of the original buildings, where the Umbdenstocks, Sauers, Ruths, Wickersheims, Hans, Zimmers, and others lived, worked, and played are still intact. (Village of Long Grove.)

Five

THE MODERN LONG GROVE

There were a lot of changes taking place in the late 1960s and early 1970s. Long Grove was setting precedent in its village planning and in its commercial district. The downtown was eventually protected as a historic district, which included the Long Grove Community Church. The commercial shopping district was settling into its reputation as a quaint shopping town. Antique shops and charming restaurants hailed the district as the "antique center of the mid-west." By the 1970s, quaint boutiques were sneaking their way into the tearooms and antique shops.

In the neighborhoods, the evolution was slow and careful. Homes that were built attempted to work around the large trees and prairies, and naturalized yards were encouraged and protected with conservancy districts. A neighborhood beautification project was started when the village provided daffodil bulbs to the residents so that they could line the streets with spring flowers. Many of the remaining farms were used for the training, boarding, and raising of horses. The community was still called semi-rural because it combined homes with woodlands, farms, and wide-open spaces.

In the 1970s, both the community and the merchants in the historic shopping district recognized the need for remembrance of the history of the area. Festivals that celebrated history, and encouraged more visitors, were becoming regularly scheduled. The town was becoming well known for its food, its history, its events, its shopping, and its trees and prairies.

Just as the land had been important to the pioneers, Long Grove, as its name implies, has remained the ground that the Native Americans crisscrossed even as time has advanced. Each generation that has lived on the land has valued the fertility and the treasures that the land possesses. The history lives on even with modern technological advances, through the character and preservation that time allows.

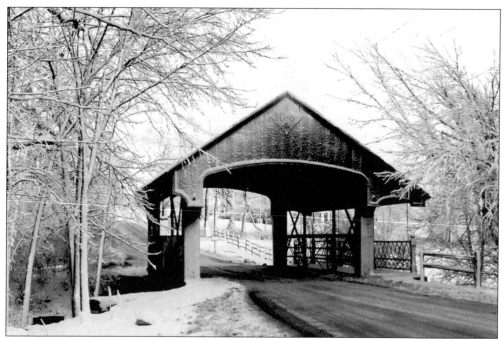

In 1973, a big change was added to the downtown when the bridge across Buffalo Creek was covered. The architect in charge was Robert Parker Coffin. Coffin served over 25 years as the village president, and eventually the roadway was named after him. (Burgess.)

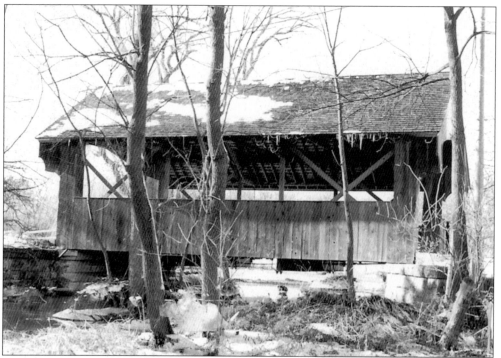

The bridge was built on the same iron trusses that dated back to the 1920s. It is presumed that a wooden bridge was originally in place, though no photographs exist. (Burgess.)

George and Carrie Umbdenstock lived in Long Grove until their deaths. When the covered bridge was dedicated, George served as the master of ceremonies for the dedication and parade. (LaMarche.)

The daffodil program begun in the late 1960s encouraged neighbors to beautify their neighborhoods with roadside plantings of daffodils. The program was so popular that by the 1990s over 10,000 daffodil bulbs were added each year. (Burgess.)

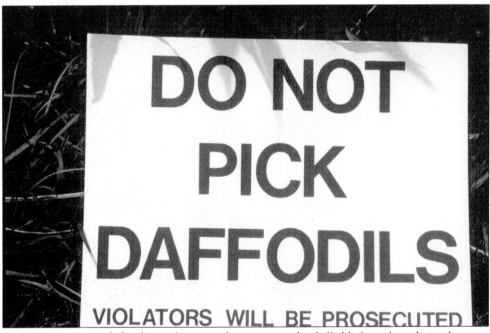

Some protection needed to be in place in order to protect the daffodils from depredation by eager humans. Village manager Cal Doughty, in the later part of the 1900s, was very good at enforcement and protection of natural areas in Long Grove and the plants that inhabited them. (C. Doughty.)

The Long Grove Park District was begun in 1973. Over time, several hundred acres of open space were acquired, which have been restored or preserved. The Reed Turner Woodland Nature Preserve was dedicated in 1974. The preserve has over 34 acres of pristine fragment woodland, part of the original Long Grove. (Burgess.)

Buffalo Creek Park, north of town behind the Village Tavern, runs along Buffalo Creek on land originally belonging to George Ruth. A gazebo was added in the 1980s, and a statue of Mercury was added in the early part of the 21st century. The statue was donated in memory of Edward Wachs, who served on the park district board for most of its existence. (Burgess.)

Some other additions to the community included the work of the Long Grove Historical Society, which formed in 1974 in an effort to save an old property called the Traeschler property. The family that had lived in the house was well known for their frivolity and was said to have held many dance parties there in the past. It was also rumored to have been an inn in the early days. The home was located on a well-traveled road, and some called it the Traeschler Tavern. The name eventually was Anglicized to Drexler. Today the Drexler Tavern serves as the village administrative buildings. The cat was also named Drexler. (C. Doughty.)

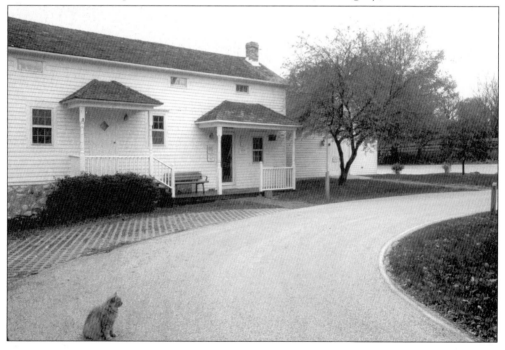

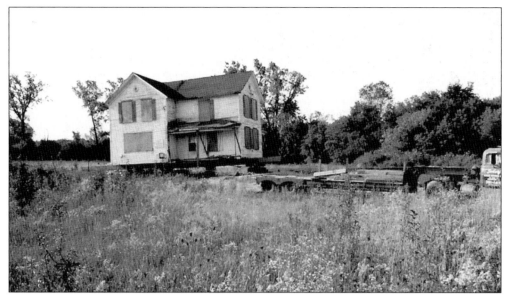

In 1986, the Long Grove Historical Society rescued a threatened building in June. A farmhouse that was located in Buffalo Grove along Buffalo Grove Road became available, and the society was given two weeks to move it before demolition. The home had been owned by the Weidner family who were farmers from the early 1850s. The society moved the house to a new location south of Robert Parker Coffin Road and west of Old McHenry Road. After renovation, the home became a museum for the society. (LaMarche.)

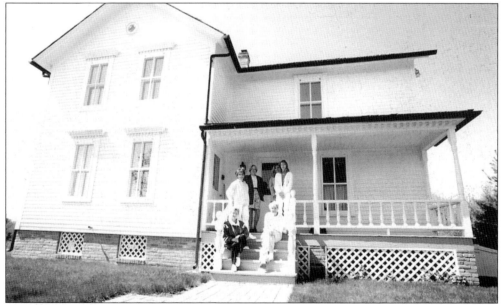

In May 1997, family members of the original Weidner family came for a tour with members of the Long Grove Historical Society. On the steps of the restored Weidner farmhouse are Margaret Weidner and her sister Shirley, Bobby O'Reilly, their two girls, and Dori Hoyne of the Long Grove Historical Society. Margaret had been born in the farmhouse and commented on the nostalgic feel of the home. She said that the parlor was fancier than she remembered but that the "farmhouse had served the family well until they had moved from the area." (Burgess.)

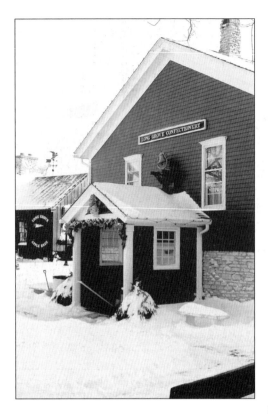

Modern buildings with historic facades were interspersed with the original buildings to add to the town's historic feel. This is the Long Grove Confectionary's Gosswiller School building named after the Gosswiller family. The building was constructed in the 1970s. (Burgess.)

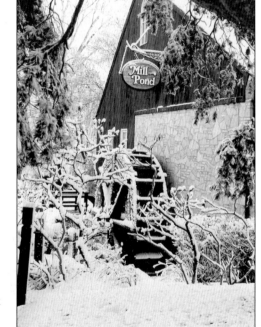

On the north side of Robert Parker Coffin Road and across the street from the bakery and the bank building, the Mill Pond complex has housed antiques, contemporary shops, and a restaurant since the 1970s. (Burgess.)

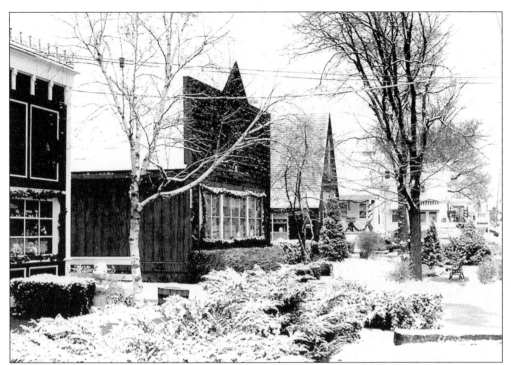

Toward the covered bridge in the downtown area, a country store was built in the 1970s, and several smaller shops were constructed to create more buildings for the shopping district. (Burgess.)

This was one of the old Sears Roebuck homes built by Walter Gosswiller and later converted into a store with many changes. (Burgess.)

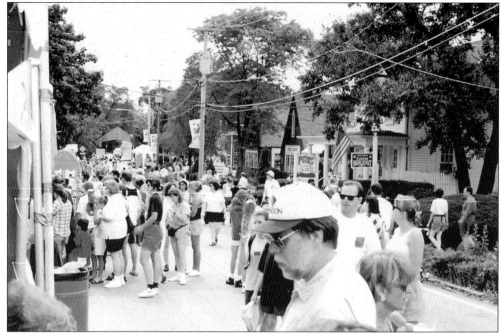

The first festival hosted by the Merchants Association was the strawberry festival. Thousands of strawberries are brought to town to create strawberry delights: strawberry shakes, chocolate strawberries, strawberry donuts, strawberry pie, and many other temptations, which lure visitors to the town during the last weekend in June each year. (Burgess.)

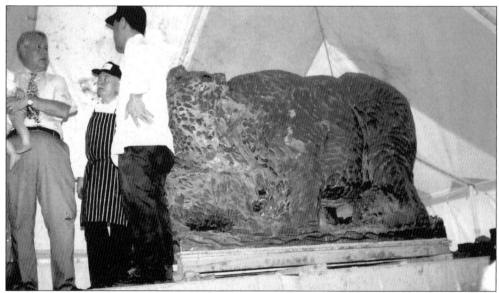

In the late 1990s, the village hosted the first chocolate festival. The Long Grove Confectionary created the world's largest chocolate bar, seen here. Confectionary owner Jon Mangel confers with his chefs while he holds his grandchild. (Burgess.)

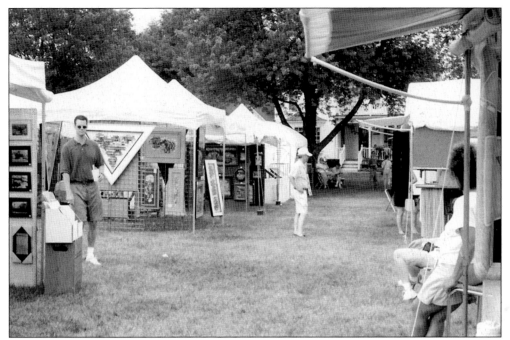

Each summer the Kildeer Countryside School, which was the original consolidated elementary school in the community, hosts an art festival to raise money for the Parent Teachers Association. Artists from all over the country sell their wares and win prizes in the juried show. (Burgess.)

An art studio was added to the community in the early 1980s. The award-winning studio has hosted international artist exhibits and assists in coordinating sculpture exhibits throughout the town. (Burgess.)

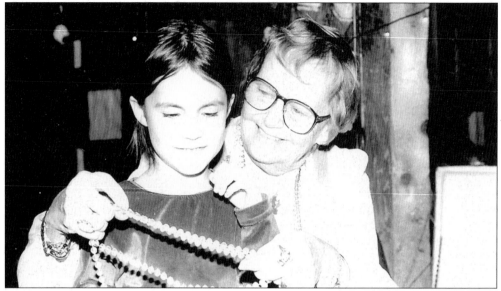

This is the Village Tavern, of the modern times. One of the favorite traditions in the Village Tavern is the visit with Mrs. and Mrs. Claus. Every year for the holidays, patrons would meet for lunch with Santa. In exchange for donations for the needy, children could tell Mrs. Claus what their wish was for Christmas. Here, Amanda Burgess visits with Norma Sayles, playing Mrs. Claus, in 1997. A longtime community member, Sayles first moved to Long Grove in the 1940s. She and her husband purchased the Village Tavern from the Didier family in the early 1950s. (Burgess.)

Each year the village celebrates a Countryside Christmas. Tree lighting ceremonies, carolers in the streets, hot spiced nuts, and even reindeer add to the holiday cheer. (Burgess.)

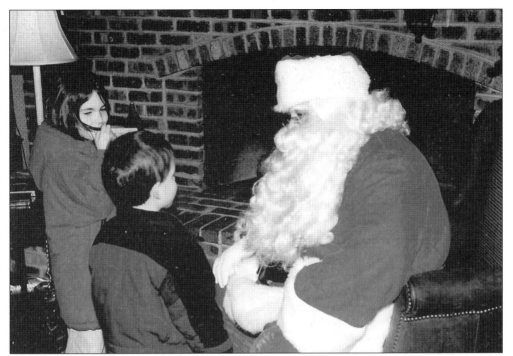

Santa Claus makes various appearances throughout the downtown during the holiday celebration. Here he listens to Amanda and Patrick Burgess in Red Oaks Fine Furnishings in 1996. (Burgess.)

Every fall the apple festival serves up apple treats, German music, and autumn fun. (Burgess.)

This is a group of intrepid natural ladies who call themselves the Earth Day Committee. They worked to build a natural butterfly garden near the village hall around 1998. The committee was made up of (first row) Barbara Turner and Kathy Wiberg; (second row) Maria Rodriguez, Lorie Lyman, Sharon Pasch, Michele Vikartofsky, Nancy Burgess, and Patty Halajian. Here, Turner is being honored by the school district for her lasting contributions to the community and its natural areas.

Edward Wachs was an active member of the community for many years. Here he is at a tree ceremony to commemorate an Earth Day tree at the Kildeer Countryside Elementary School around 1998. Students from the school helped to plant the tree. (Burgess.)

Features that attracted the pioneers are still present in the community even in a modern society. Flower displays are sprinkled throughout the business district. And the large trees that shadow the community are still present. (Burgess.)

Even as time has passed, the village of Long Grove remains as a testament to the German pioneers who founded the community. Much of the land that George Ruth described as fertile with "Indians crossing freely" is still intact even as several generations have come, gone, and left their marks. (Burgess.)

BIBLIOGRAPHY

Al Capone Museum, www.myalcaponemuseum.com

Brown, Clayton W. *A Little Bit of History, The Village of Kildeer*. Illinois. 1996.

Chicago Historical Society web site, www.chicagohistory.org

Dretske, Diana. *What's in a Name? The Origin of Place names in Lake County, Illinois*. Lake County Discovery Museum. Second edition.

Halsey, John J., LL.D. *History of Lake County Illinois*. Roy S. Bates, 1912.

Hill, Robert. *Oral History*. Vernon Area Public Library, 1987.

Keefe, Rose. *Guns and Roses*. Nashville, TN: Cumberland House Press, 2003.

McAlester, Virginia and Lee McAlester. *A Field Guide to American Houses*, Alfred a Knopf, Inc., 1984.

Naden, Don. *The Independent Register*. June 22, 1972.

Park, Virginia L. *Long Grove Lore and Legend*. Long Grove Historical Society, 1978.

Past and Present of Lake County Illinois, Chicago, IL: Wm. Le Baron and Company, 1877.

"Prairie Farmers Reliable Directory of Farmers and Breeders of Lake County." *Prairie Farmer*, Chicago, 1917.

Pukite, John. *A Field Guide to Cows*. Penguin Books, 1998.

Scharf, Albert F. *Indian Trails and Villages in Lake County Illinois*. 1919.

Sigwalt family records, Henry Sigwalt and Leona Sigwalt (née Heiland). *Down Memory Lane: A Family Story*. 1984.

Snetsinger, Robert J. *Kiss Clara for Me*. Pennsylvania: Carnation Press, State College, 1969.

Taylor, Alberta. "Long Ago in Long Grove." *Vernon Town Crier*, August 26, 1965.

Tryzyna, Sophia H. *One Quarter Section*, Vernon Area Public Library, 1973.

Vernon Town Crier. History section, February 28, 1973.

Westerman, Al. *Public Domain Land Sales for Lake County, Illinois*. 2005.

INDEX

ACROSS AMERICA, PEOPLE ARE DISCOVERING SOMETHING WONDERFUL. *THEIR HERITAGE.*

Arcadia Publishing is the leading local history publisher in the United States. With more than 3,000 titles in print and hundreds of new titles released every year, Arcadia has extensive specialized experience chronicling the history of communities and celebrating America's hidden stories, bringing to life the people, places, and events from the past. To discover the history of other communities across the nation, please visit:

www.arcadiapublishing.com

Customized search tools allow you to find regional history books about the town where you grew up, the cities where your friends and family live, the town where your parents met, or even that retirement spot you've been dreaming about.

MAP SEARCH